WYOMING

a photographic journey

FARCOUNTRY PRESS

photography and text by Kyle Spradley

Right: Beauty is everywhere and in all sizes in Wyoming. As you hike along a mountain-fed stream or through an alpine meadow, keep your eyes peeled for the colorful, well-traveled monarch butterfly.

Far right: Rising high above the surrounding hills, the otherworldly formation of Devils Tower glows at sunset. The country's first designated national monument offers camping, hiking, and ranger programs and is a popular rock climbing destination.

Title page: Located in the Wind River Range of western Wyoming, Black Joe Lake wraps around the north side of Haystack Mountain and provides backcountry campers splendid rainbow trout fishing.

Front cover: Aspen trees light up the Blair-Wallis area of Vedauwoo, a popular recreation destination near Laramie.

Back cover: Wyoming summers are short, but the patient hiker is rewarded with an abundance of magical landscapes across the country's 44th state, including the Gap Lakes Trail in the Snowy Range. These weathered peaks were sculpted by erosion and glaciers, leaving numerous alpine lakes.

ISBN: 978-1-56037-738-2

© 2019 by Farcountry Press

Photography © 2019 by Kyle Spradley.
Text by Kyle Spradley.

For more information about our books, write Farcountry Press, P.O. Box 5630, Helena, MT 59604; call (800) 821-3874; or visit www.farcountrypress.com.

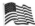 Produced and printed in the United States of America.

23 22 21 20 19 1 2 3 4 5 6

*To my wife, **Caitlyn**, for being there with me for most of these photo shoots. Whether that meant a 3 a.m. wake-up call or plowing through snowdrifts on a Wyoming backroad, she has supported all my crazy adventures just to get a photo of a place.*

*And to my parents, **Chris and Bill**, for showing me the allure of the outdoors and always being my biggest fans.*

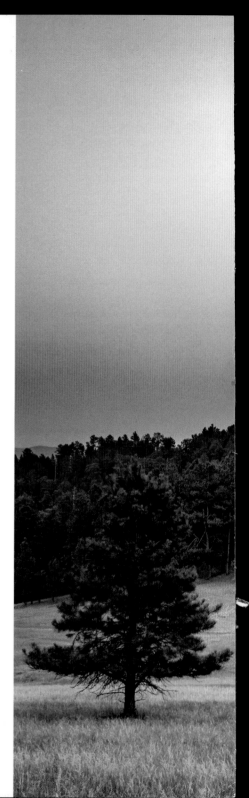

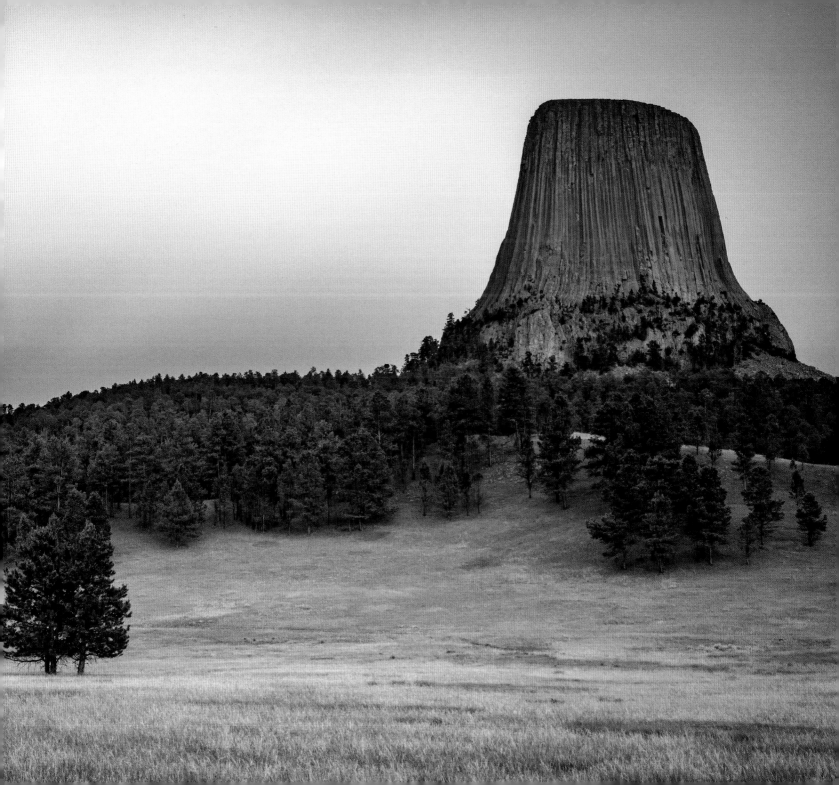

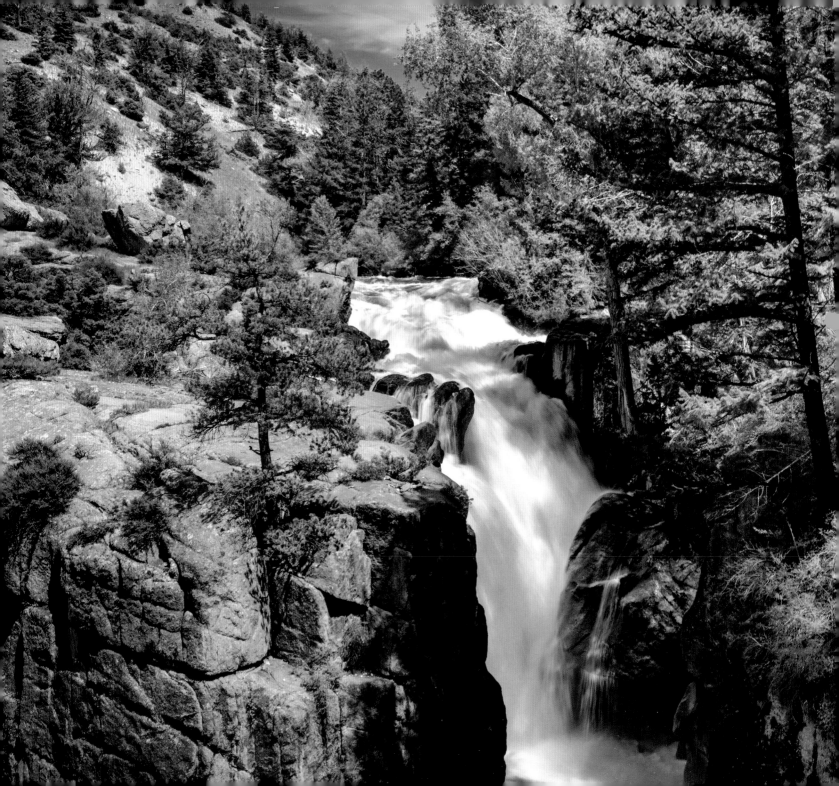

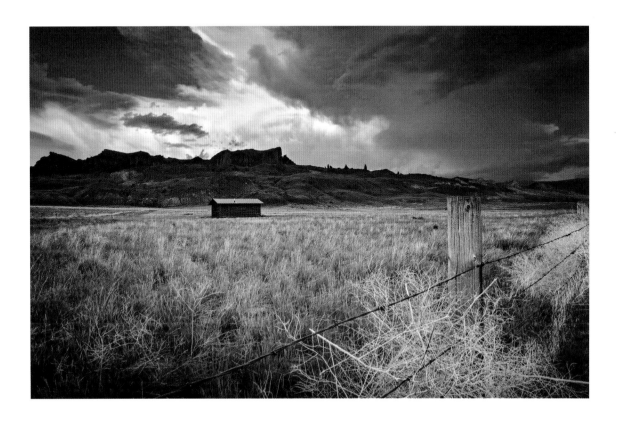

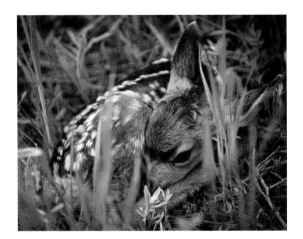

Above: The dramatic drive along U.S. Highway 14 from Cody to Yellowstone National Park is full of western flare and epic landscapes. President Theodore Roosevelt called it "the most beautiful 50 miles in America." This humble outbuilding in the Wapiti Valley sits off the highway beneath pinnacles of dark igneous rock, remnants of the region's violent volcanic past.

Left: After a mother mule deer gives birth, she often leaves the fawn tucked away in tall grass or under a bush while she forages nearby.

Far left: Spring snowmelt cascades down Shell Canyon in Bighorn National Forest. A few steps from the parking lot along U.S. Highway 14 east of Greybull lead to a boardwalk over the creek and a breathtaking view of Shell Falls. The canyon is named for the shell fossils found in the sedimentary walls.

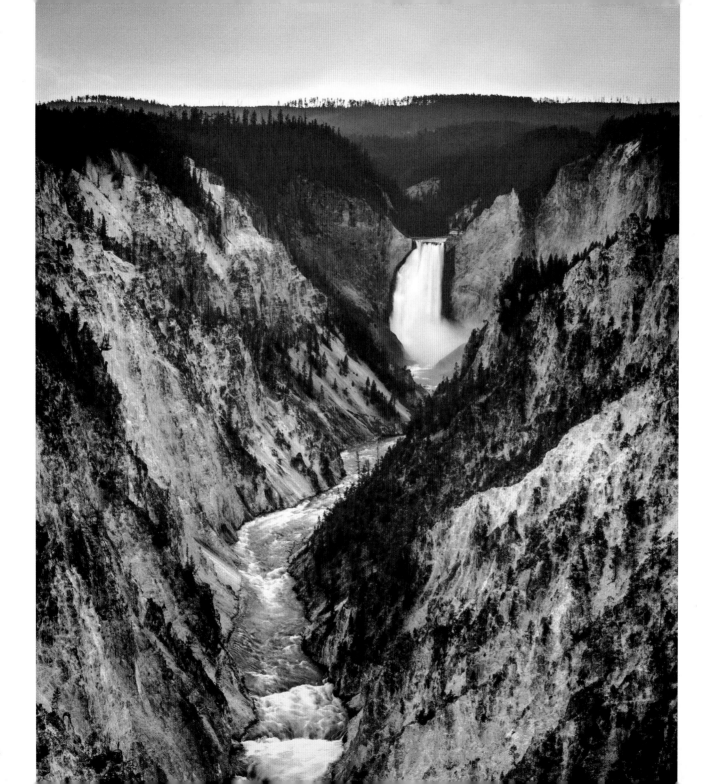

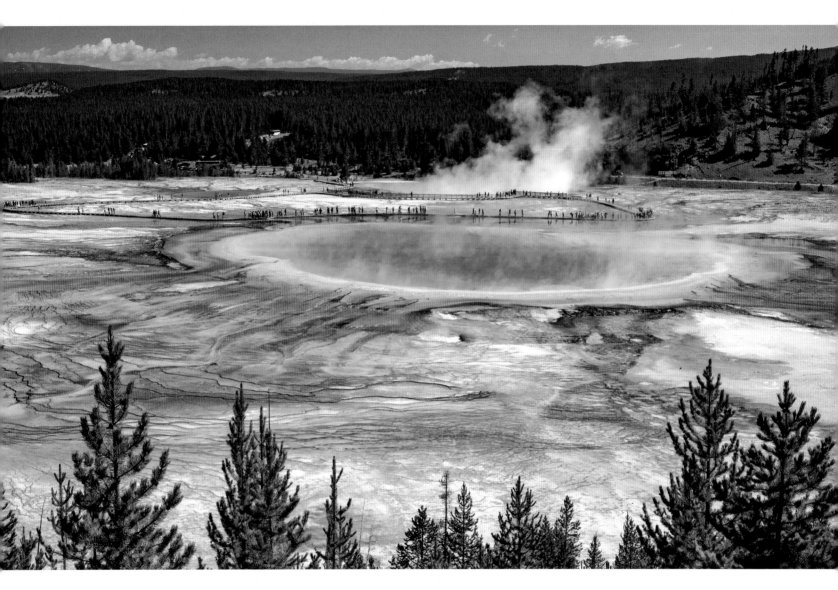

Above: Located in Yellowstone National Park, Grand Prismatic is the largest hot spring in the United States and the third largest in the world. The spring is approximately 370 feet wide and 121 feet deep. Geologists with the Hayden Geological Survey in 1871 bestowed its name for the striking coloration.

Facing page: Aptly named Artist Point provides a picture-perfect view of Lower Falls and the Grand Canyon of the Yellowstone. Canyon depths range from 800 to 1,200 feet as the Yellowstone River roars past massive boulders, sheer cliffs, and bright yellow geologic formations.

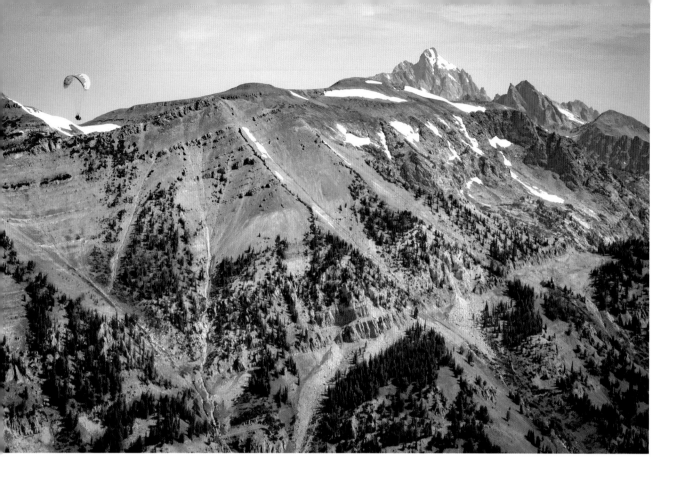

Above: Jackson Hole Mountain Resort is an adventurer's haven. Take the Aerial Tram for spectacular views of the Teton Valley. Hike back down the mountain to shops and restaurants, or go for the ultimate rush and paraglide across the valley for unique views of the Teton Range.

Right: A mountain goat enjoys the cool mountain air.

Far right: One of the most famous scenic routes in the United States is the Beartooth Highway, a National Scenic Byways All-American Road. Constructed in the 1930s, it climbs to an altitude of nearly 11,000 feet past alpine lakes and meadows to give stunning vistas of Wyoming and Montana. Because of heavy winter snow, the road is only open from late May to September.

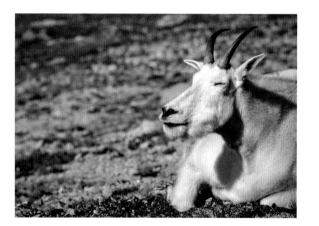

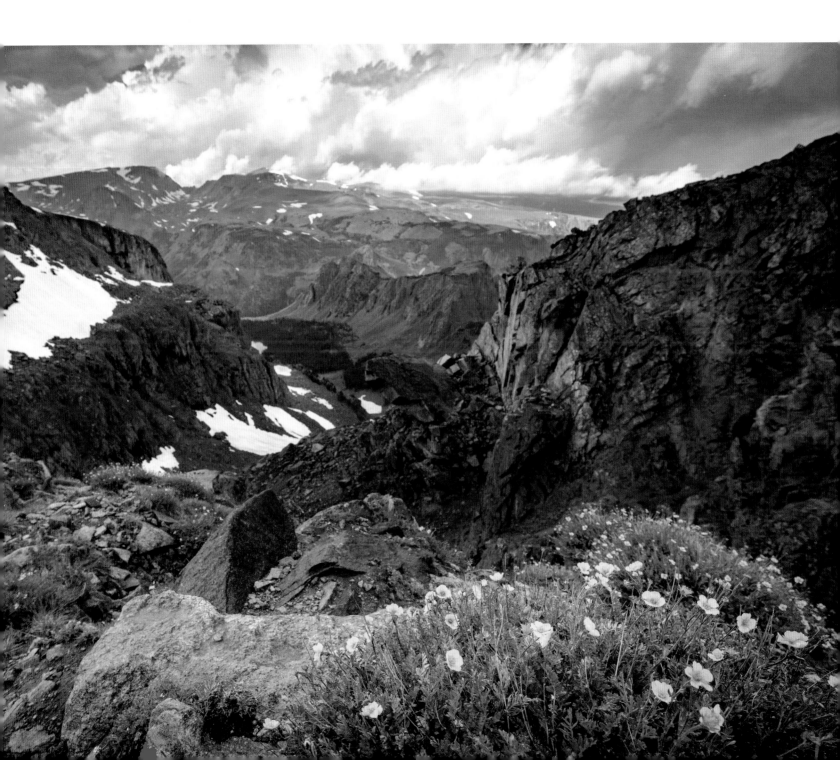

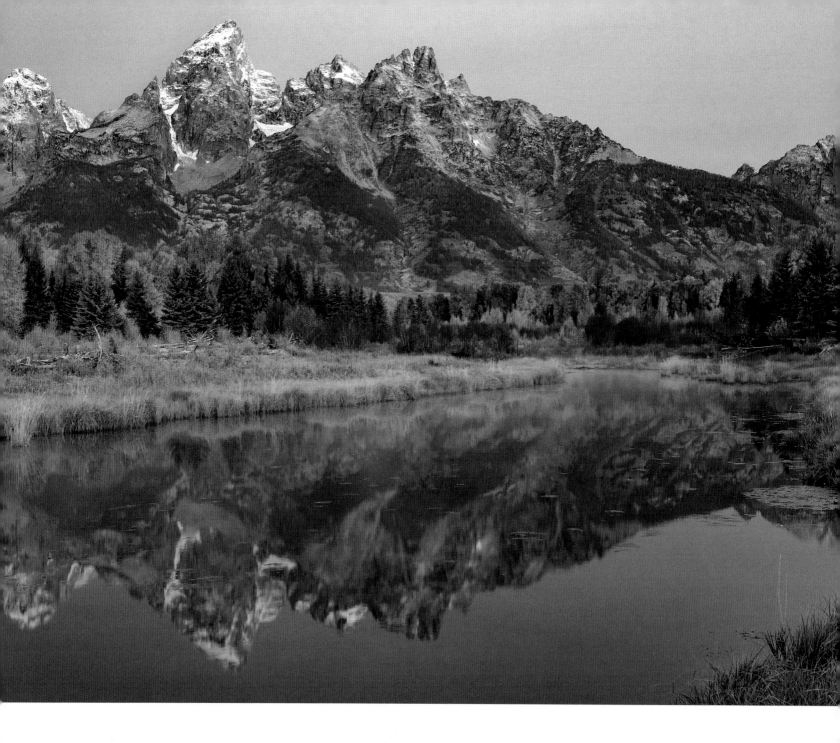

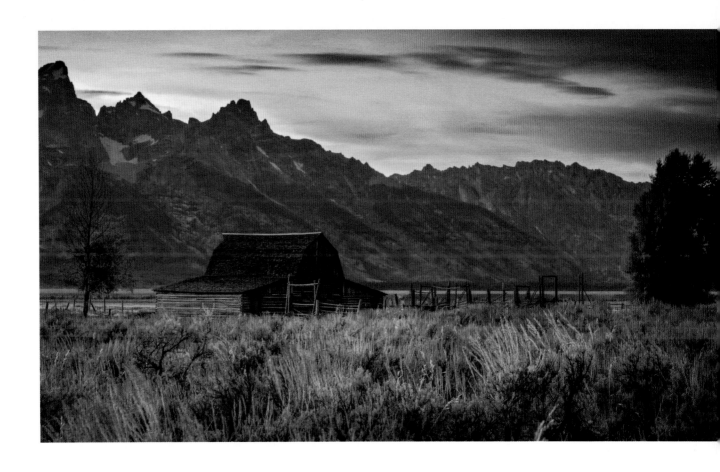

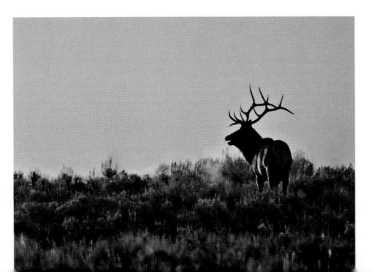

Above: The harsh winters kept everyone but natives and fur trappers out of Jackson Hole until the 1880s, when pioneers began to settle the area. Some of the original homesteads are preserved along Mormon Row. The most celebrated is the T. A. Moulton Barn.

Left: The high-pitched bugle bull elk use to round up their harem of females is both eerie and effective.

Far left: Schwabacher Landing in Grand Teton National Park is easily the most iconic location in the park. Each morning photographers line up long before sunrise to catch a postcard moment of this picturesque bend in the Snake River.

Above and facing page: Fort Laramie was originally established as a private fur trading post in 1834. Its initial popularity was tied to its location at the confluence of the Laramie and North Platte Rivers, and it grew into a popular stop on the Oregon Trail for trappers, emigrants, soldiers, homesteaders, and miners. Later, it became a large and well-known military post and was a staging point for troops and supplies during the Civil War and the Great Sioux War of 1876. After the transcontinental railroad was built, its importance declined, and it eventually closed in 1890.

Right: Local pride in Upton led to the preservation of its historic Old Town. The original Irontown was built on this site near Iron Creek in the 1880s with hopes of becoming a big railroad town. The town soon declined but rebounded in the 1890s when it became a railroad supply station. The name was later changed to Upton. The buildings have been restored and include a blacksmith shop, fire hall, water tank, barn, corral, log homes, and various cabins.

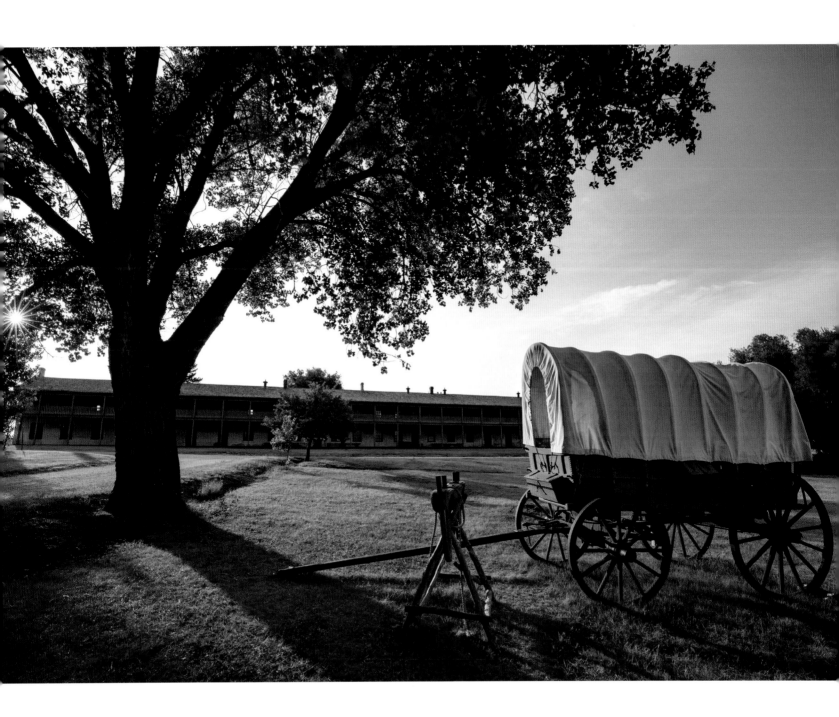

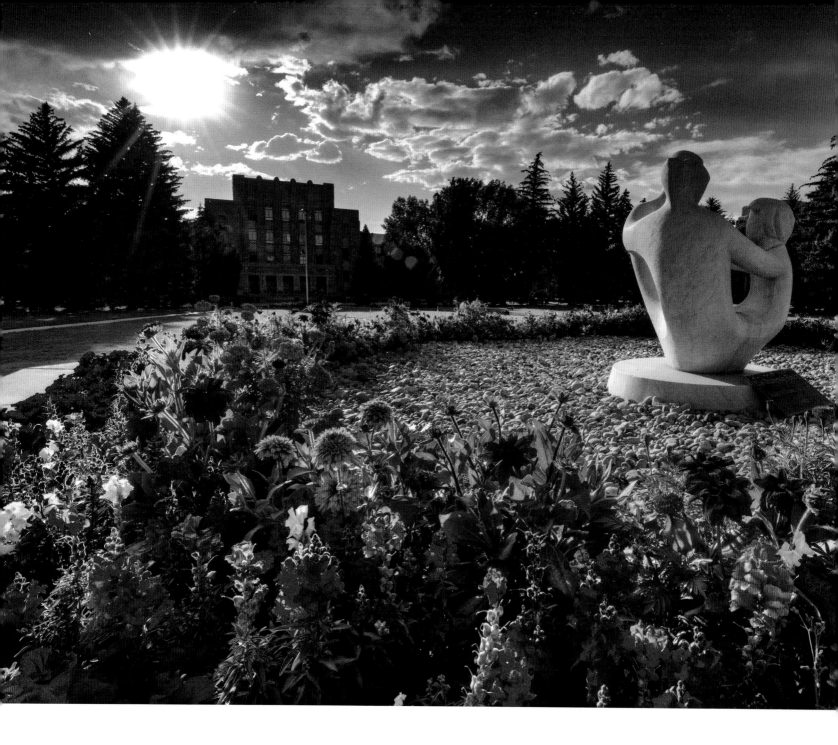

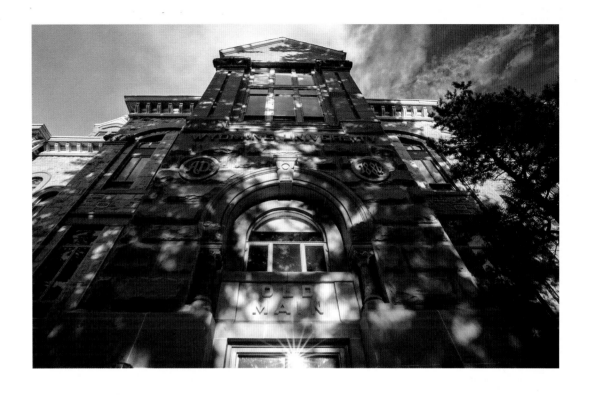

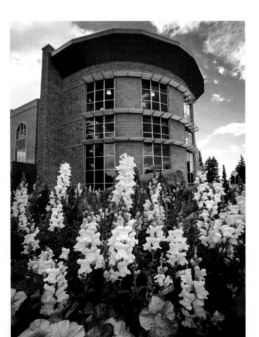

Above: The University of Wyoming in Laramie was founded in 1886, and Old Main was it's first building. The rough-cut sandstone structure in the Romanesque Revival style set the architectural tone for the campus. Opened in 1887, Old Main is listed on the National Registry of Historic Places and is still in use today.

Left: A main hub of campus activity is the Half Acre Recreation and Wellness Center, where students, staff, and faculty workout, swim, play basketball, and scale the indoor climbing wall.

Far left: The *University Family* statue sits in the middle of Prexy's Pasture on the UW campus in Laramie. Rather than a central quad, UW has a greenspace where an early UW president, Arthur G. Crane, kept horses near his office. "Prexy" is short for president.

Right: Lupines bloom on the forest floor in the Bighorn Mountains. You can find these blue-to-purple blooms throughout woodlands and meadows from June to August, often in large bunches, creating a picture-perfect scene.

Far right: From atop a rock outcropping, a panoramic view unfolds of the Cloud Peak Wilderness outside Buffalo. Named for the tallest mountain in the area—13,167-foot Cloud Peak—the nearly 190,000-acre wilderness area spans 27 miles of the Bighorn Range.

Below: A mountain biker cruises along a new section of trail during a late summer ride. Wyoming is known for world-class mountain biking, and the Happy Jack Recreation Area in the Medicine Bow National Forest features a wide variety of trails for novice to advanced riders.

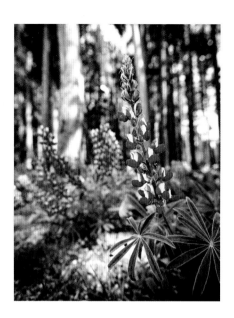

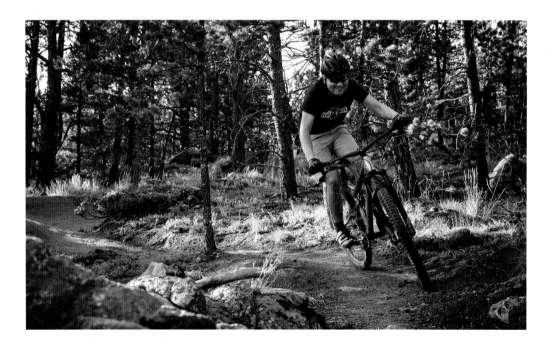

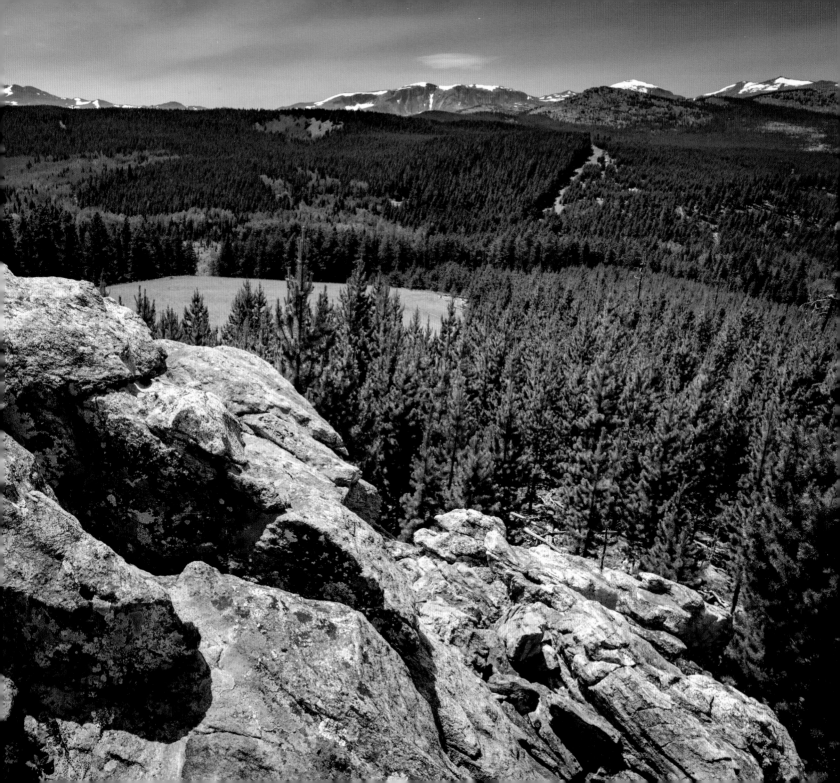

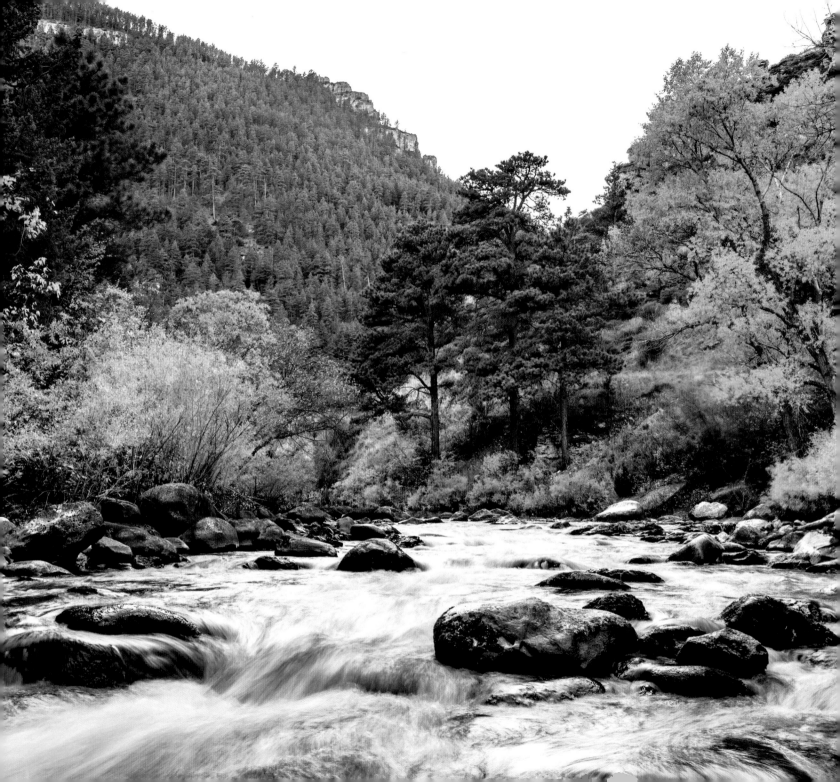

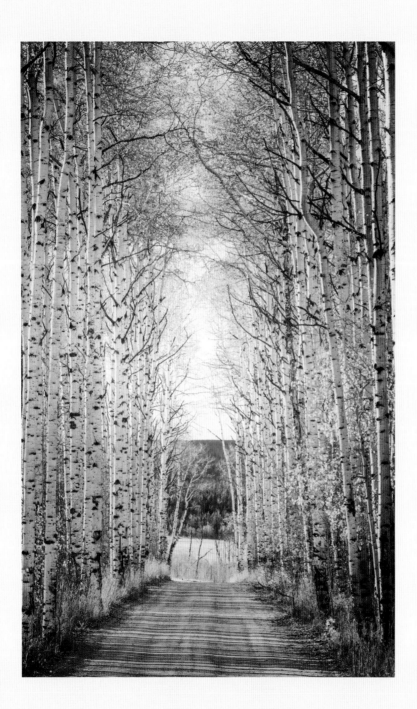

Above: Fresh frost on aspen leaves means peak color will soon begin in the Snowy Range.

Left: Aspen Alley in the Sierra Madre Range near Encampment is a postcard location any leaf peeper should visit. There are no signs or official markers on a map identifying this location, but all the locals know about it. In the fall, the road is frequented by folks taking in the glow of the aspen leaves through the grove.

Far left: The Tongue River, a tributary of the Yellowstone River, originates in Wyoming, fed from melting snowpack in the Bighorn Mountains. It tumbles through Tongue River Canyon near Dayton, passing beneath beautiful shale and sandstone cliffs.

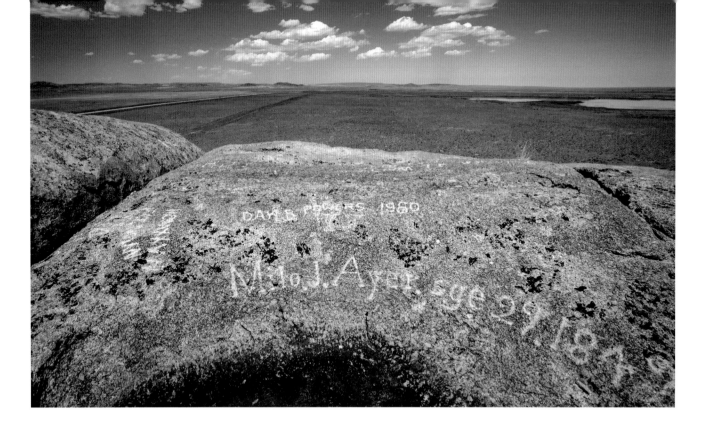

Above: Independence Rock, a giant monolith at the southeast end of the Granite Mountains in Natrona County, was a famous sight on the Oregon, Mormon, and California Trails. Over a period of three decades, more than 500,000 emigrants passed by this rock; many of them carved their names into it as a rite of passage, with the earliest visible name appearing around 1824. Wagon parties believed that if they reached the rock by July 4th, they would arrive in California or Oregon before the first snowfall.

Right: The Oregon Trail left impacts not only on our culture, but on the landscape as well. Located in Guernsey is the Oregon Trail Ruts State Historic Site. Travelers sought a route around the marshes along the North Platte River. With their wagons loaded down with goods, the wheels carved two-to-six feet deep into the soft sandstone, leaving behind ruts for visitors to view today.

Far right: The rock formation at Ayres Natural Bridge Park near Douglas is a popular picnic and camping spot for people in east-central Wyoming. Wade in the cool, clear waters of La Prele Creek as you take in this natural wonder.

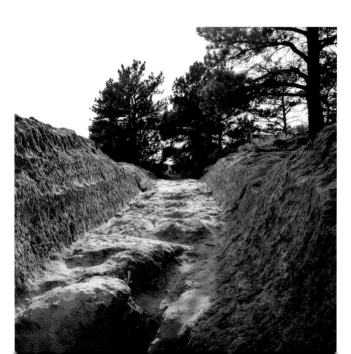

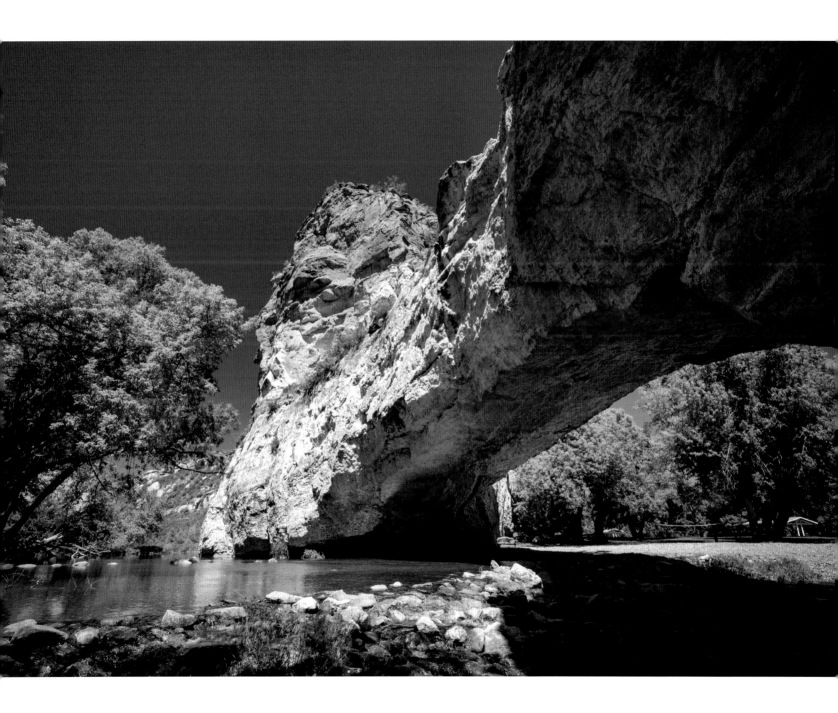

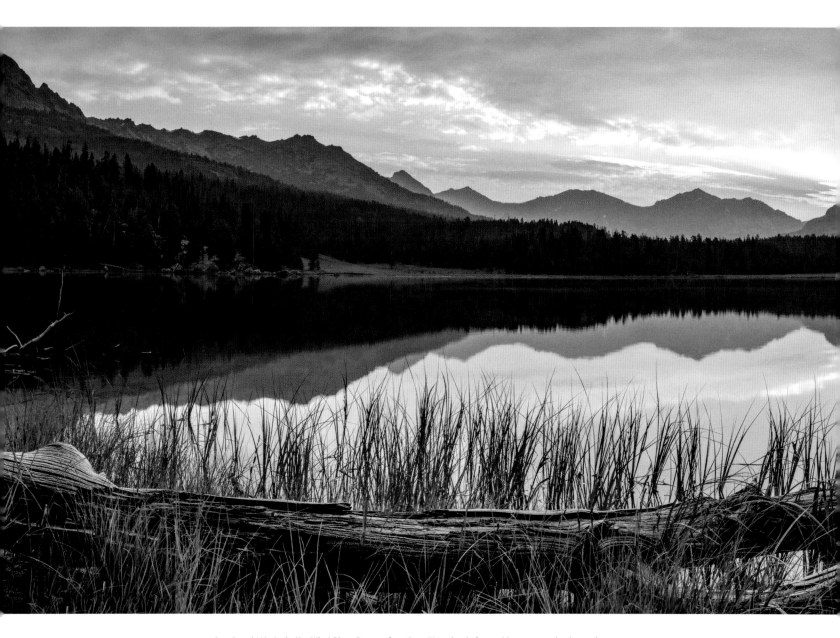

Sunrise at V Lake in the Wind River Range of western Wyoming is framed by panoramic views of high-elevation peaks. During summer, the lake is popular with backcountry campers and anglers.

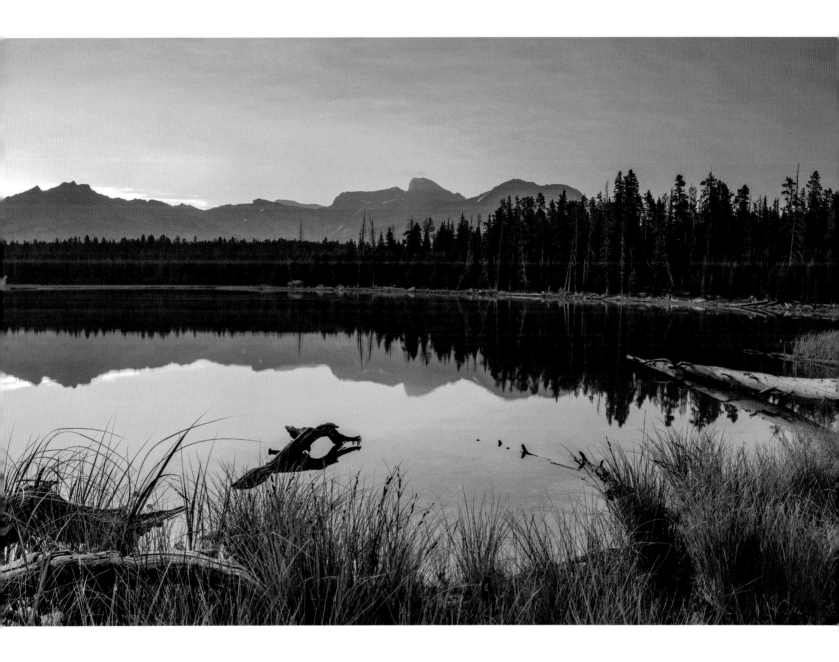

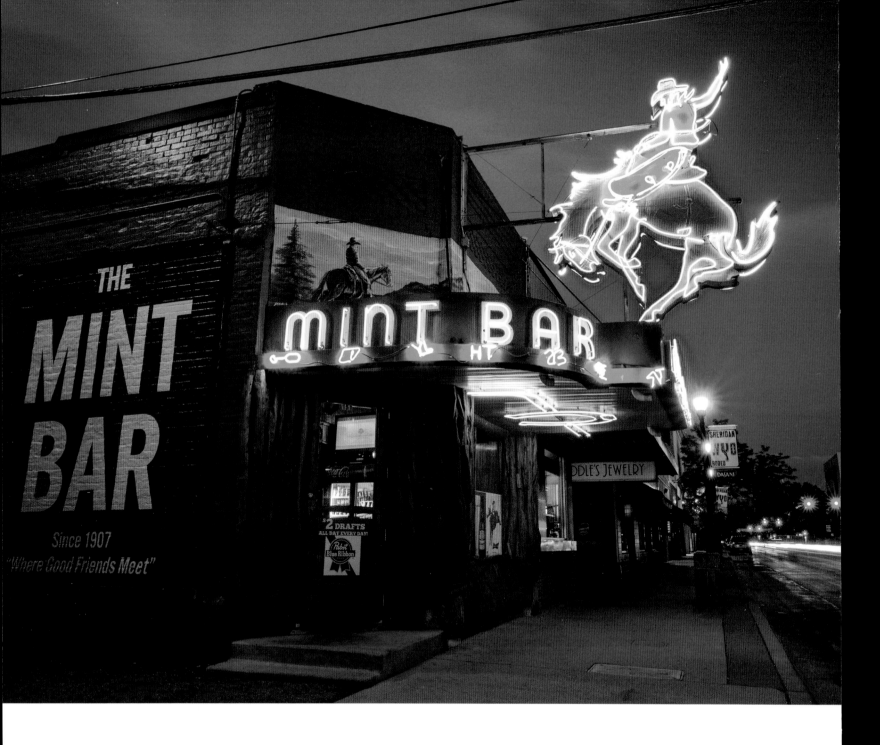

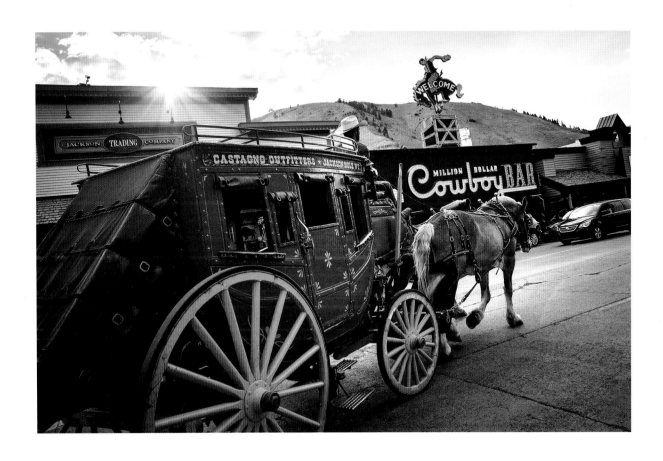

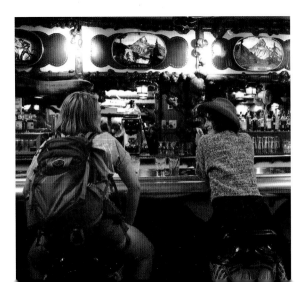

Above: In downtown Jackson, a horse-drawn stagecoach takes visitors around the town square and past the famous Million Dollar Cowboy Bar.

Left: Inside the Million Dollar Cowboy Bar, patrons can belly up to the bar on worn-in saddles. Opened in 1937, the bar is known for its bar covered with silver dollars, knobbled-pine décor, live music scene, country-western dancing, and colorful cowboy murals.

Far left: Known as "Wyoming's Meeting Place," the Mint Bar in Sheridan got its start in 1907. During Prohibition, it was known as the Mint Cigar Company and Soda Shop, with a speakeasy in the back room. Today, tourists and locals alike slake their thirst with a variety of libations and eyeball the collection of taxidermied animals, cattle brands, and a giant Texas rattlesnake skin.

Above: On the outskirts of Cody, the bouldered hillsides of Cedar Mountain provide a sprawling view of the town named after William "Buffalo Bill" Cody, one of the most famous figures in cowboy culture.

Right: Pronghorn might as well be a state symbol. Their population is fairly equal to the human population across the state. Pronghorn can reach speeds of 60 miles per hour, making them the world's second-fastest land mammal behind the cheetah.

Far right: In the Medicine Bow National Forest west of Glendo, the Esterbrook area features striking views of outcroppings and pine forests. It's a popular destination for camping and elk hunting.

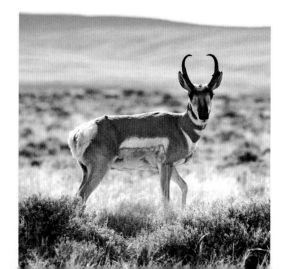

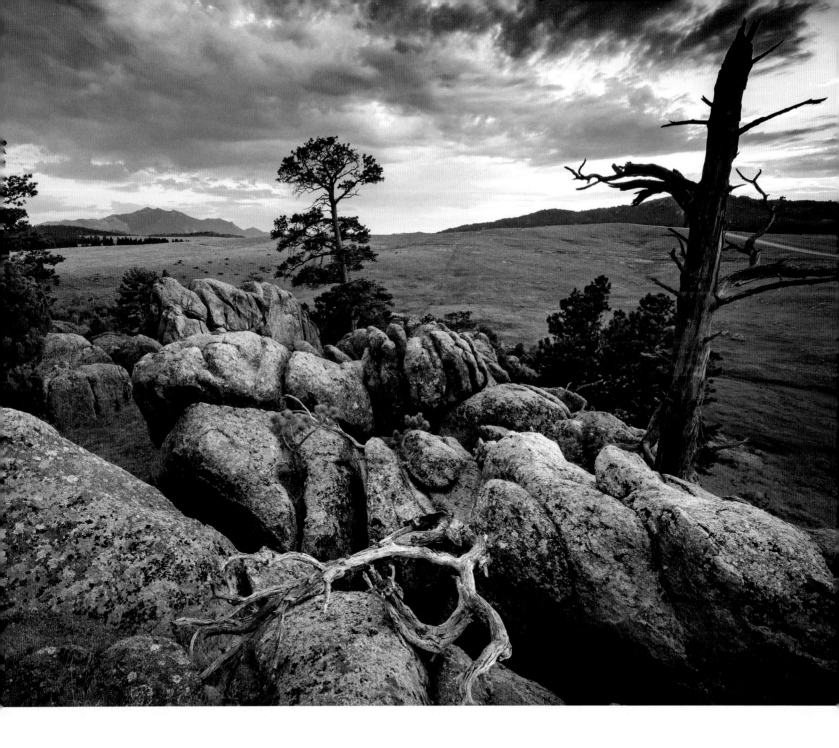

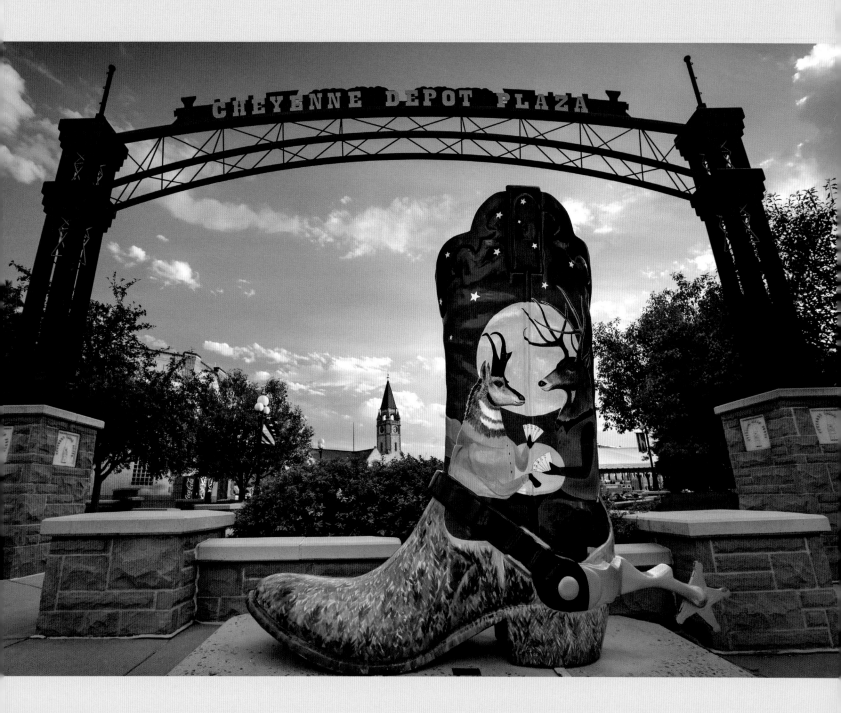

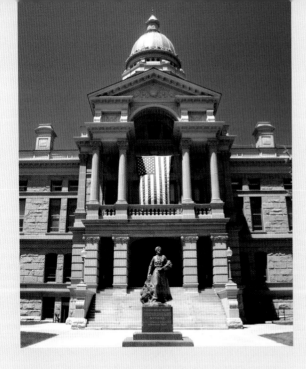

Left: Construction began on the Wyoming State Capitol in Cheyenne in 1886 and was completed in 1890, when Wyoming Territory gained statehood. Designed in the Renaissance Revival style, the sandstone building has been renovated for the digital age while preserving historical features.. PHOTO © DANNY DAUSTADT/DREAMSTIME.COM

Far left: Wyoming is popularly known as "The Cowboy State," a reputation embraced in the capital no less than in far-flung ranch towns. Since 1897, Cheyenne Frontier Days has drawn huge crowds every July to the world's largest outdoor rodeo and western celebration, with big-name musical performers, a carnival midway, grand parade, and Indian village. You'll see rodeo influences all across the booming town, including the eight-foot-tall cowboy boots painted by local artists. Grab a map at the Depot to search for them all.

Bottom left: The importance of the railroad in the history of Cheyenne cannot be overstated. The Union Pacific Railroad reached the city in November 1867; with it came great anticipation for growth and prosperity. Today, the railroad is still a major economic force in the region. The historic Union Pacific station has been restored and renamed the Cheyenne Depot, containing a visitor center, restaurant, and museum.

Bottom right: The Phoenix Block in the Downtown Cheyenne Historic District has housed a wide range of retail outlets since its construction in 1882. Today, it's home to 13,000 square feet of ranch and western wear framed by the glow of a massive Wrangler marquee sign.

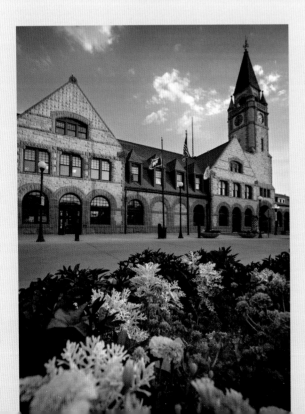

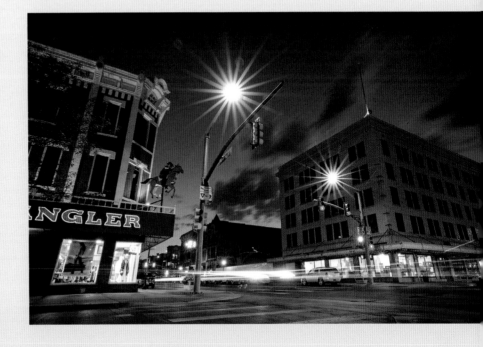

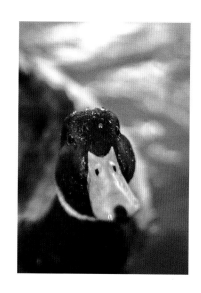

Right: A curious male mallard peeks at the camera.

Far right: Talk to anglers across the state about "fishing the Platte" and you're bound to get a lively collection of fishing stories. The stretch of the famed waterway outside Saratoga is known nationwide as a prime place for lunkers.

Below: Few National Historic Sites are known for their blue-ribbon fishing and epic tubing waves, but Expedition Island in the town of Green River is full of surprises. John Wesley Powell started his 1869 and 1871 explorations of the Green and Colorado Rivers here. Today, the island is a park with whitewater features—a challenging plunge on the south side of the island and a gentler run on the north side.

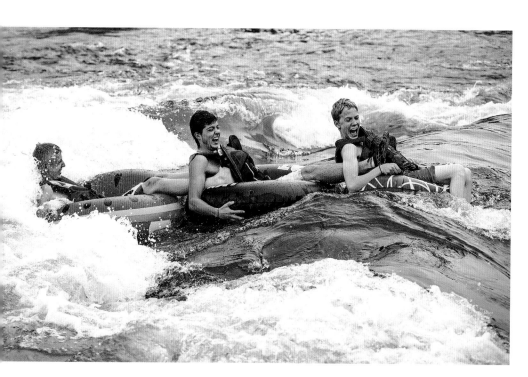

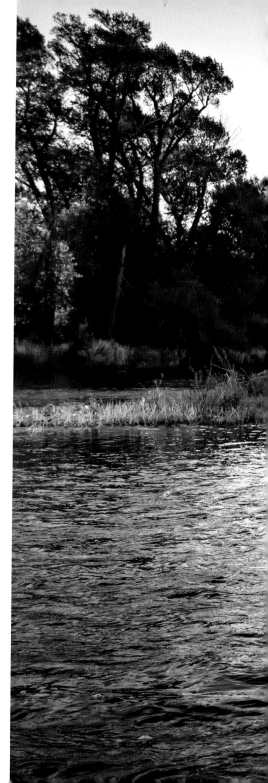

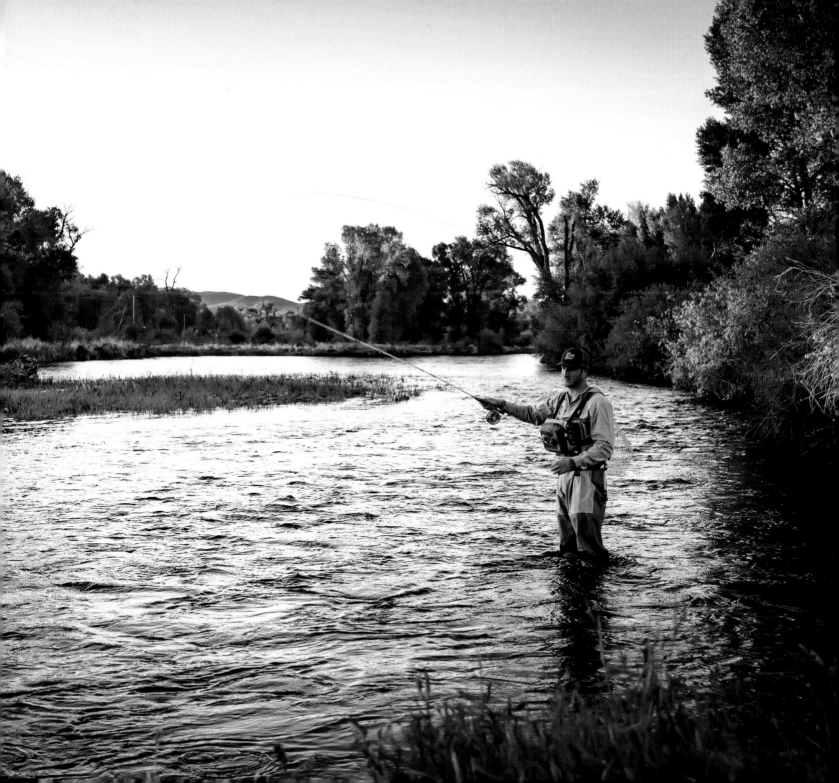

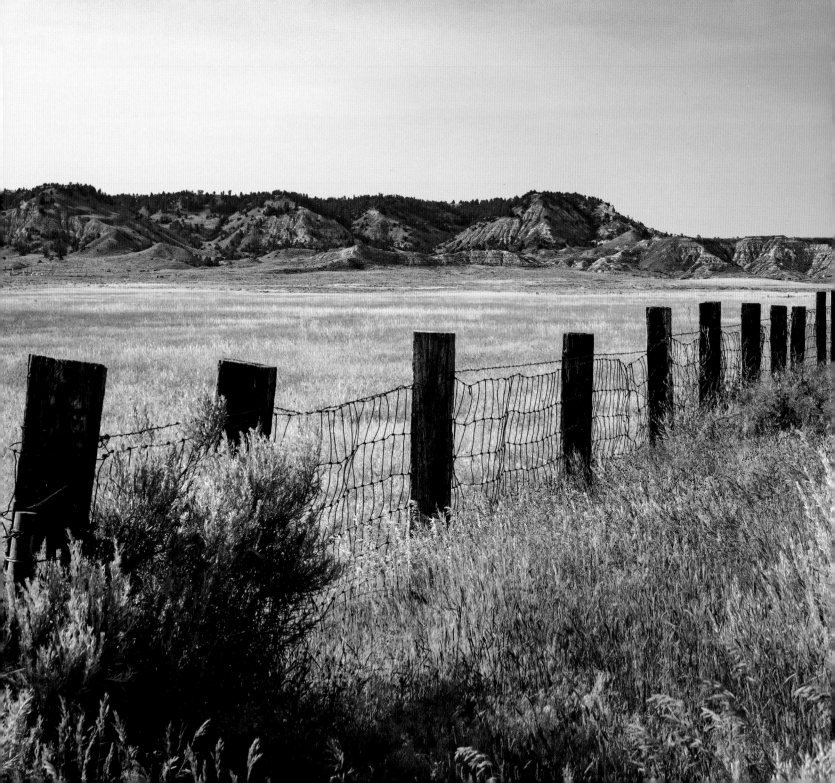

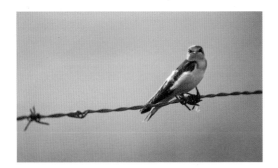

Left: A barn swallow rests on a barbed-wire fence.

Far left: The only grassland in the United States managed by the National Forest Service is Thunder Basin National Grassland. Spreading west of the Black Hills, Thunder Basin encompasses five counties with more than 500,000 acres of semi-arid land protected for wildlife and livestock. The grasslands also provide habitat for more than 100 species of birds.

Below: Picturesque farms and ranches dot the rolling hills of Sheridan County in northern Wyoming.

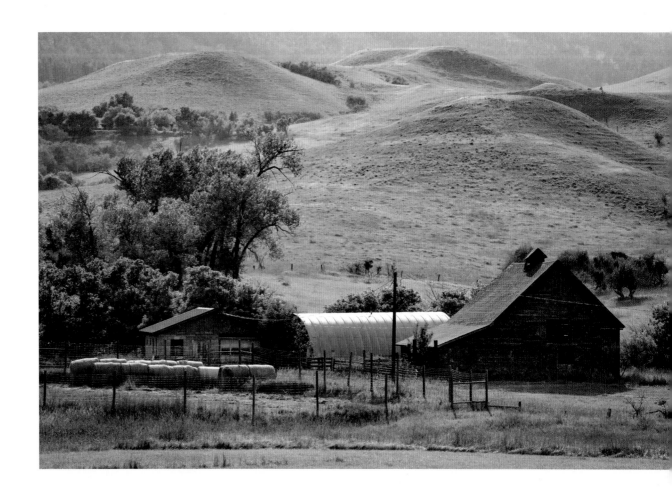

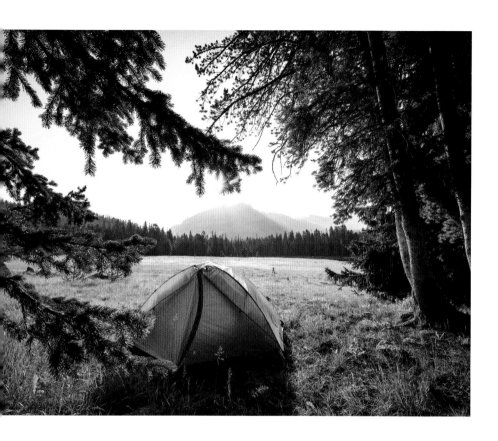

Above: Sunrise warms a backcountry campsite in the Wind River Range.

Right: A spotted sandpiper patrols the shores of an alpine lake.

Far right: Just a short hike from the Big Sandy Campground in the Wind River Range, Diamond Lake provides breathtaking panoramic views of the surrounding jagged peaks.

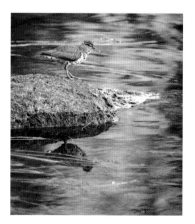

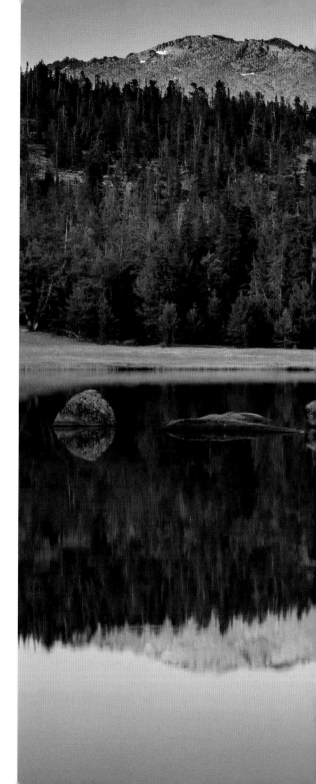

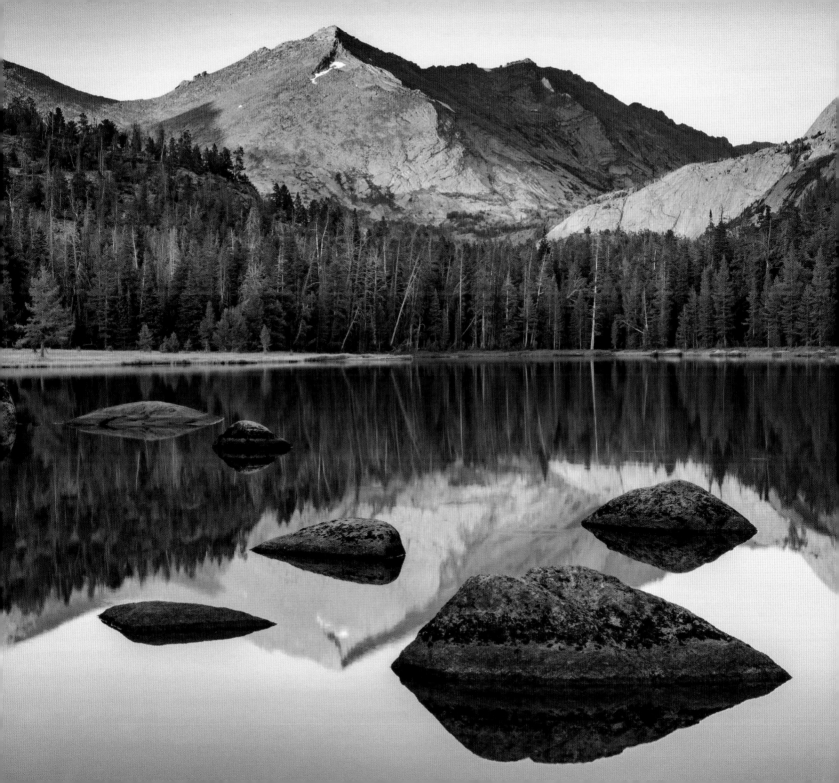

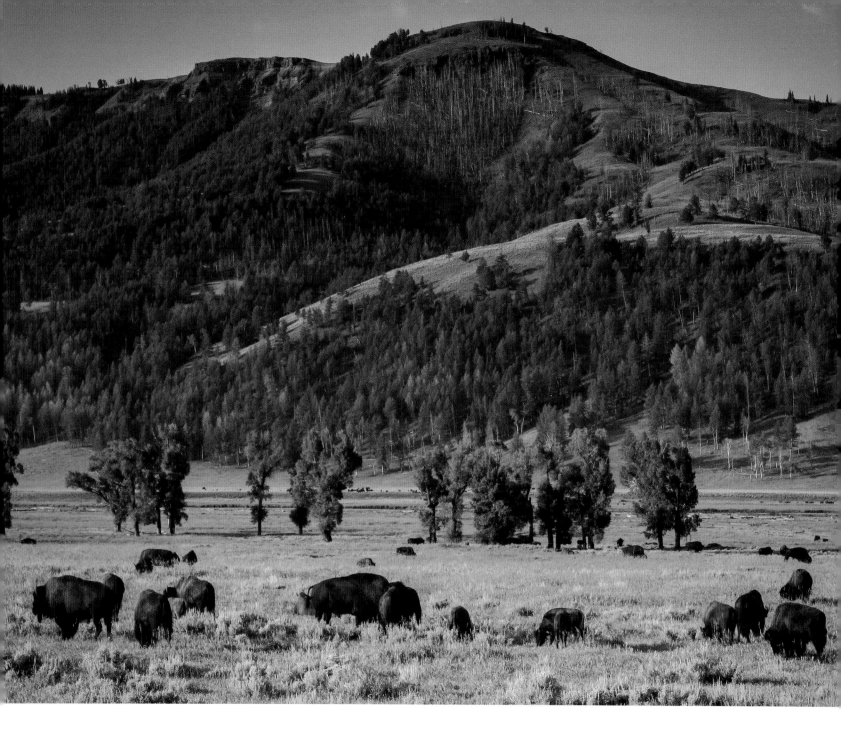

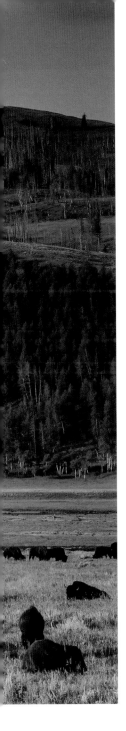

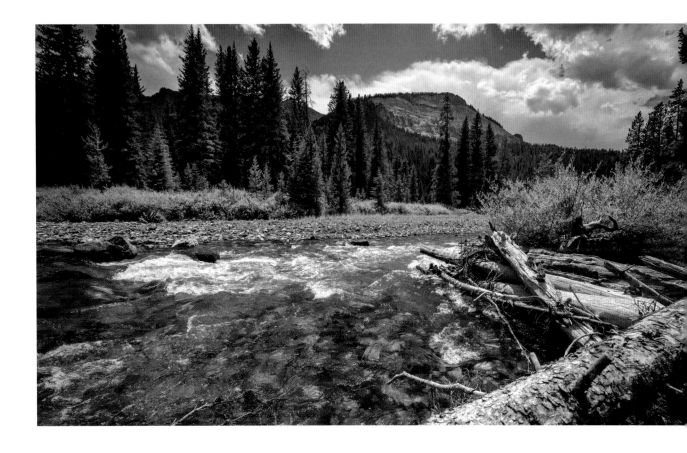

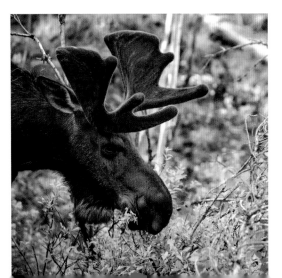

Above: Soda Butte Creek runs through Yellowstone National Park's northeastern corner. A major tributary of the Lamar river, Soda Butte Creek is a popular destination for anglers looking to reel in its brook, cutthroat, and rainbow trout.

Left: Wander along almost any marsh or creek, morning or evening, in Wyoming, and you're bound to see North America's tallest mammal —the moose. This prehistoric-looking mammal's diet primarily consists of leaves, pinecones, bark, and tree and shrub buds.

Far left: Wyoming's state mammal, the bison, roams the Lamar Valley in Yellowstone National Park. The valley is often called "America's Serengeti" thanks to its varied and vibrant population of wildlife, ranging from packs of wolves and herds of elk to osprey, grizzly bears, and bald eagles.

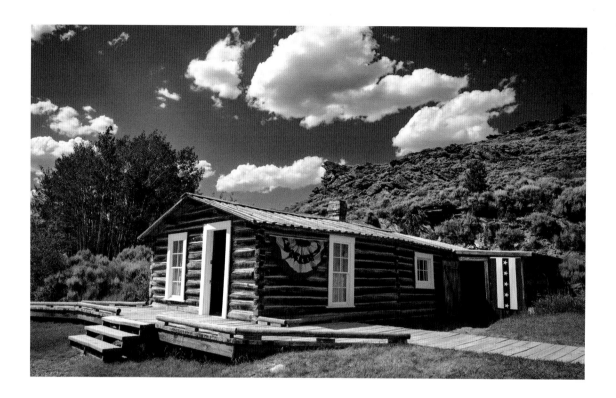

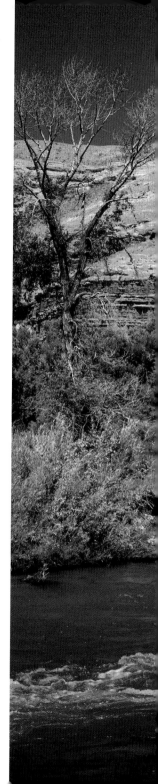

Above: The historic mining area of South Pass City in Fremont County is now a ghost town but was once a stop on the Oregon Trail. It began as a stagecoach and telegraph station during the 1850s. In the 1860s, gold was discovered in the vicinity, and soon the town's population swelled to about 2,000. By the turn of the twentieth century, the town had dwindled to less than 100, but the buildings have since been restored and are now a beloved tourist destination.

Right: The famous *Jackalope* statue sits outside the Douglas Railroad Interpretive Center. This monument honors the fabled creature that first became part of the folklore of Douglas in the 1930s. Douglas Herrick, a local taxidermist, is credited with creating and spreading this truly American tale.

Far right: Travelers on U.S. Highway 26 along the Wind River are justifiably tempted to dip their toes in the cool water. On the 20-mile stretch east of Dubois, it's also easy to be distracted by stunning rock formations lining the canyon.

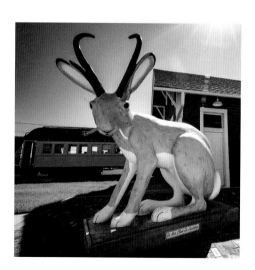

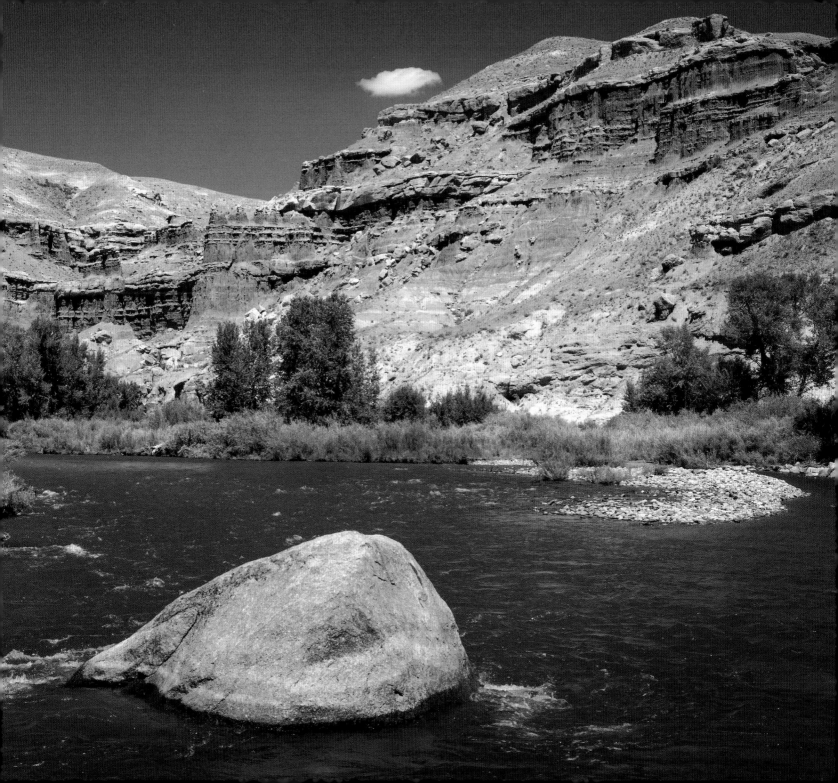

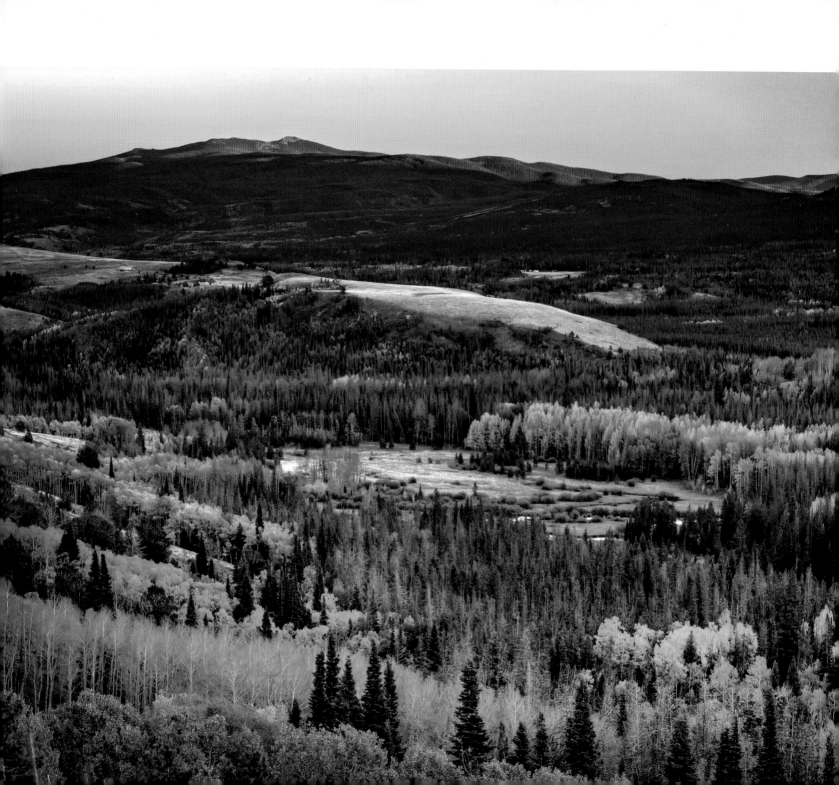

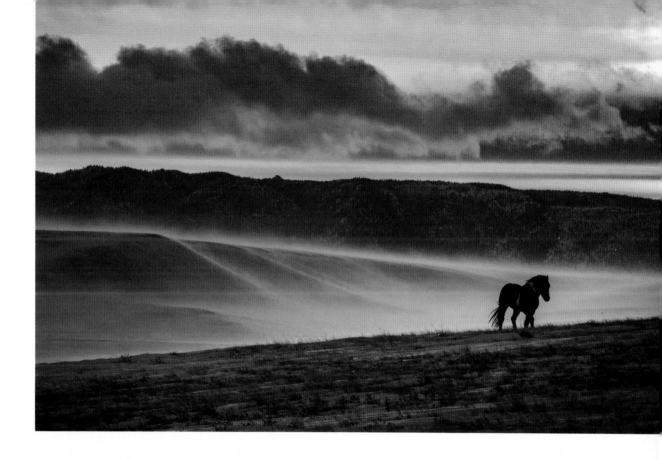

Above: Winters can be unrelenting in Wyoming. With subzero temperatures and blowing snow blanketing most of the state for months on end, it's difficult to imagine life existing here. Nevertheless wildlife, domestic animals, and people somehow manage to survive each winter to jubilantly welcome the mild seasons ahead.

Left: Blooms of a vervain flower are set aglow by the setting summer sun.

Far left: The Sierra Madre Range, near Encampment, is perfect for an autumn sojourn. Meander along Battle Pass Scenic Byway (Wyoming Highway 70), crossing the Continental Divide and famed Continental Divide Trail, over mountain passes, and down into golden meadows. Be sure to pause at Battle Lake overlook about 2 miles west of Battle Pass' 9,955-foot summit.

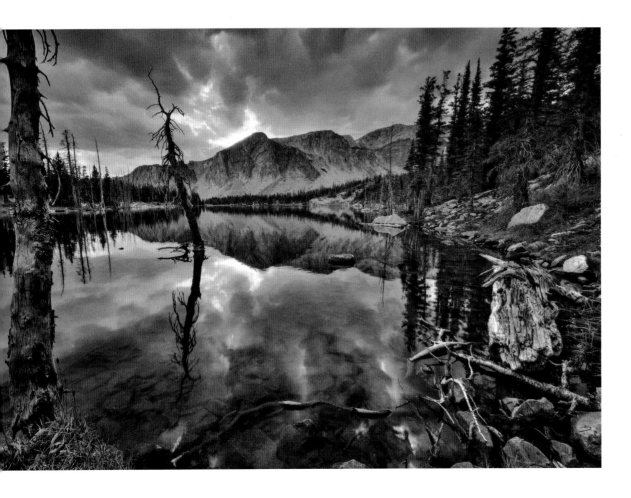

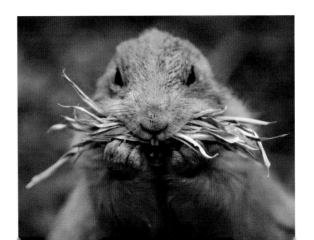

Above: Summer storm clouds are illuminated above Medicine Bow Peak and reflected in the waters of aptly named Mirror Lake in the Snowy Range.

Right: A prairie dog feasts on summer's bounty.

Far right: Wind River Lake nestles in the pines just east of Togwotee Pass in western Wyoming. The popular picnicking spot off U.S. Highway 26 lies within Shoshone National Forest, the country's first designated national forest.

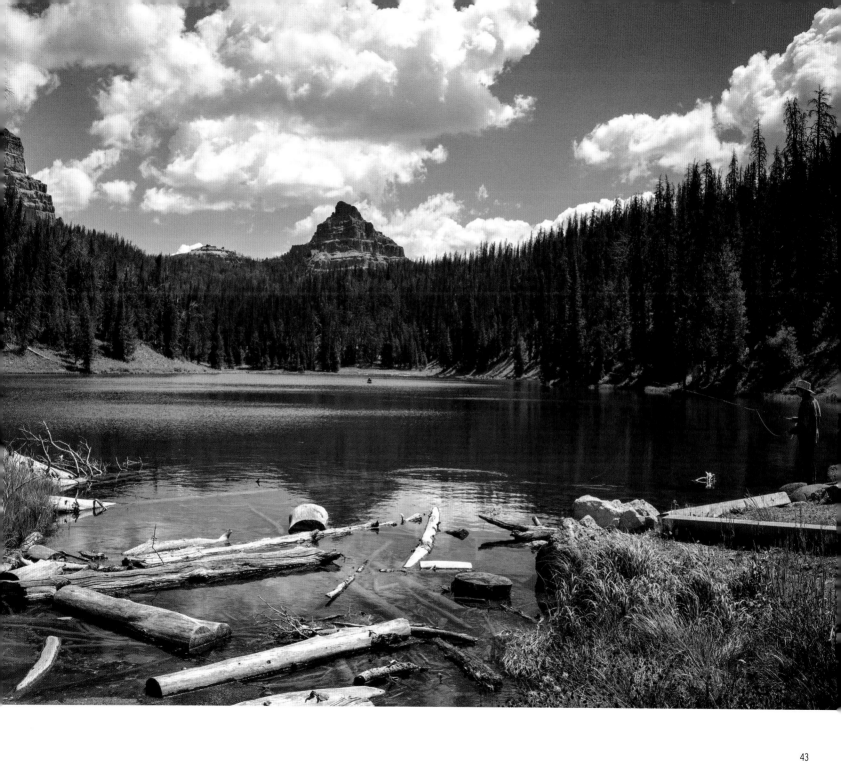

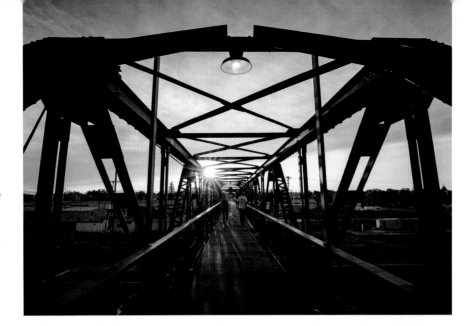

These pages: Walk through downtown and you'll soon see why Laramie is dubbed the "Gem City of the Plains." Stroll past the many building-sized murals, catch the sunset from atop the pedestrian bridge, or stop to savor the many flavors of western culture mixed with modern style.

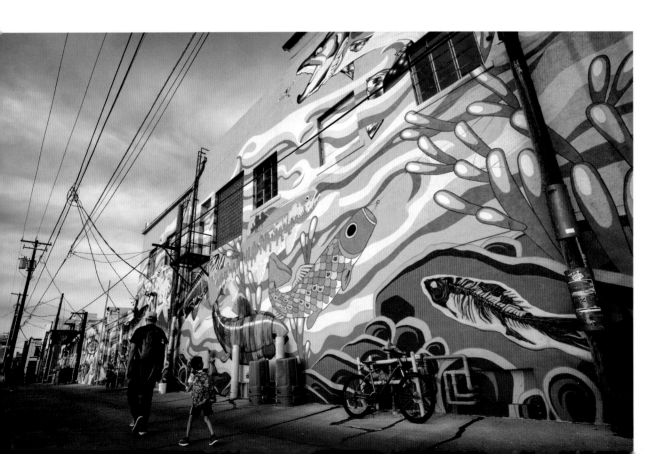

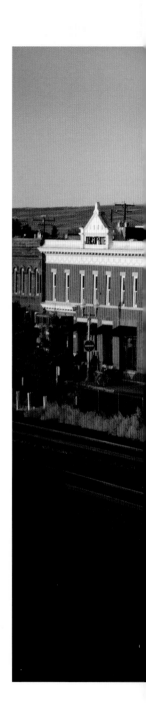

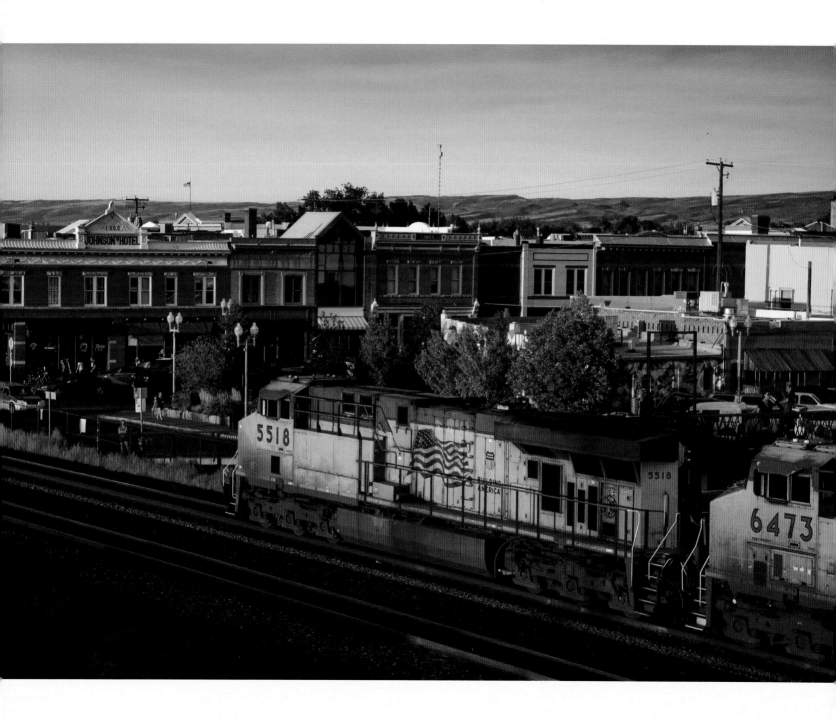

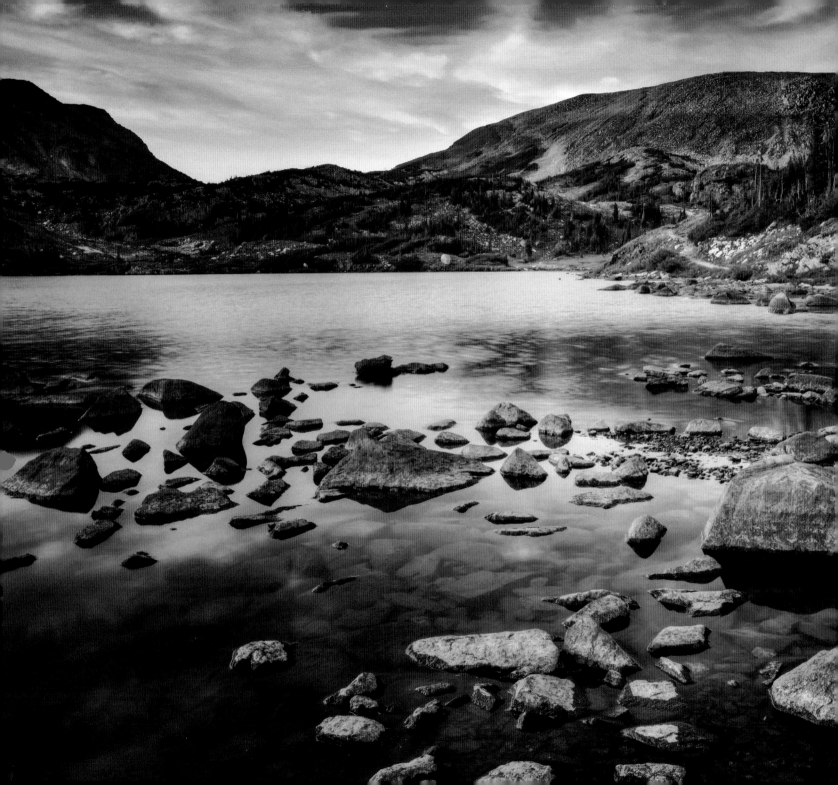

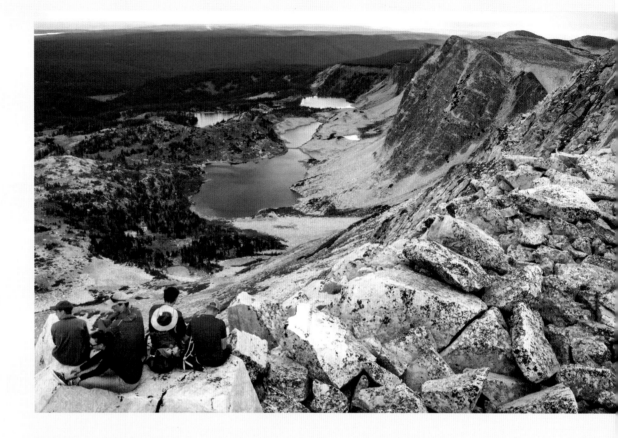

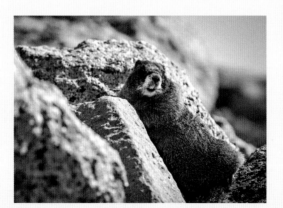

Above: University of Wyoming students rest at the summit of Medicine Bow Peak in the Snowy Range. Medicine Bow reaches an elevation of 12,013 feet and provides a panoramic view of the Wyoming plains, the Park Range, and the high-elevation landscapes of northern Colorado.

Left: Stop along any alpine hike and listen for the high-pitched chirp of a marmot. These large members of the squirrel family can be seen scurrying around the rocks and nooks of boulder fields and hillsides across the state.

Far left: Sunset gilds the shores of Lewis Lake in the Medicine Bow National Forest.

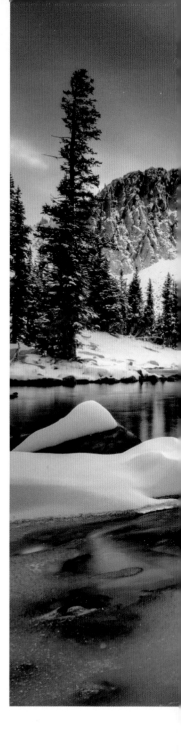

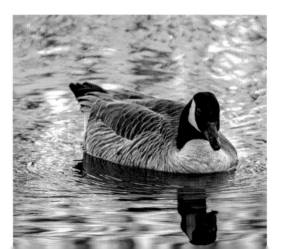

Above: Fresh snowfall dusts Medicine Bow National Forest near Centennial in autumn. The mountains of Wyoming often see a mix of weather, in this case contrasting the warm colors of aspen leaves with the cooler hues of fresh snow.

Right: A Canada goose cruises across a lake as the late afternoon sun warms the waters.

Far right: The high-altitude environment of Lake Marie just off the Snowy Range Scenic Byway may see snow anytime of the year. The byway, which connects Laramie with Saratoga, is typically open from Memorial Day to late October.

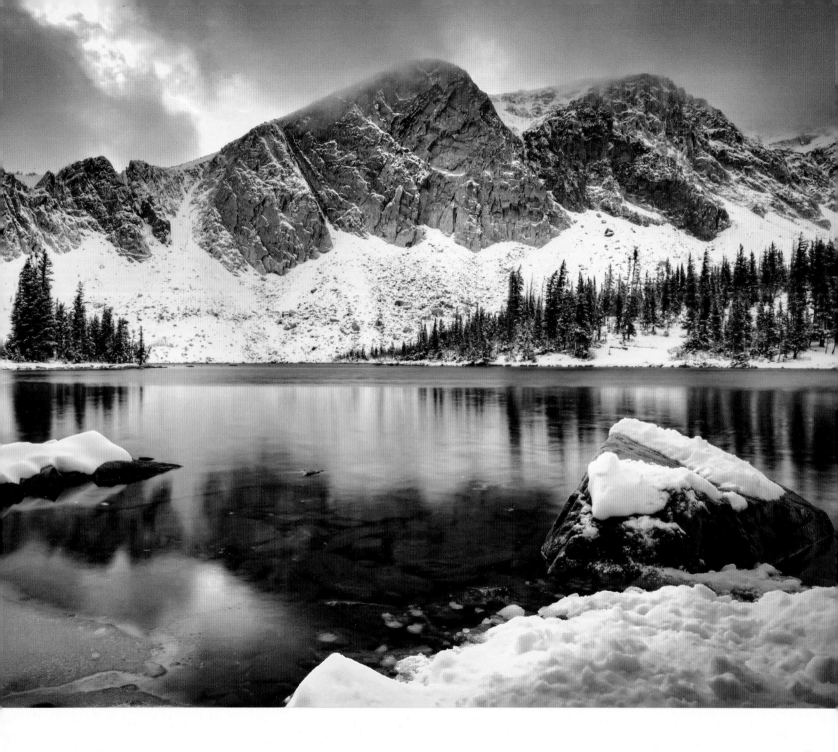

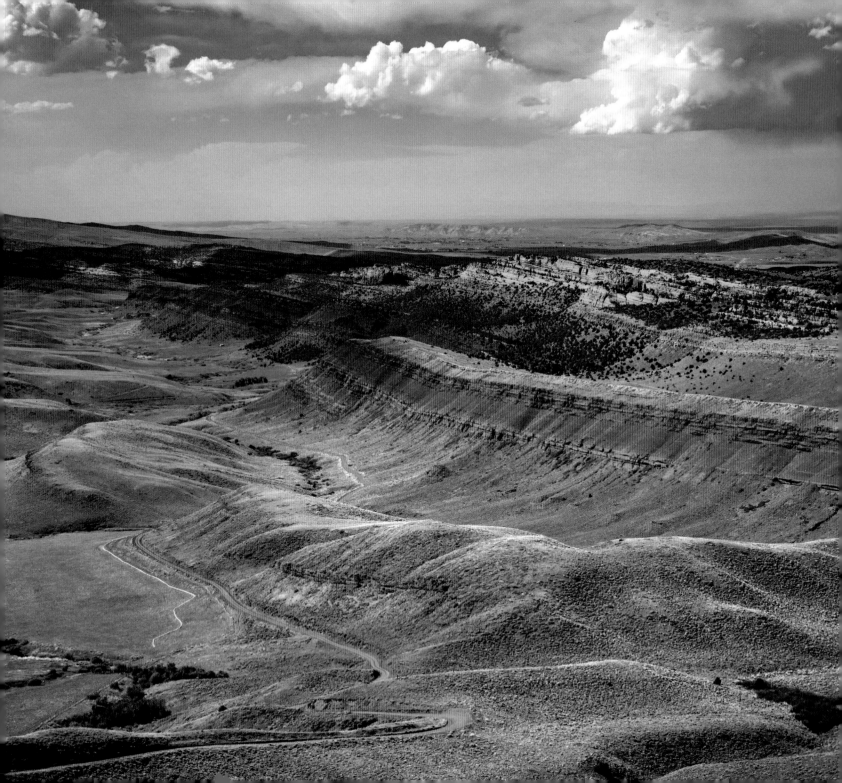

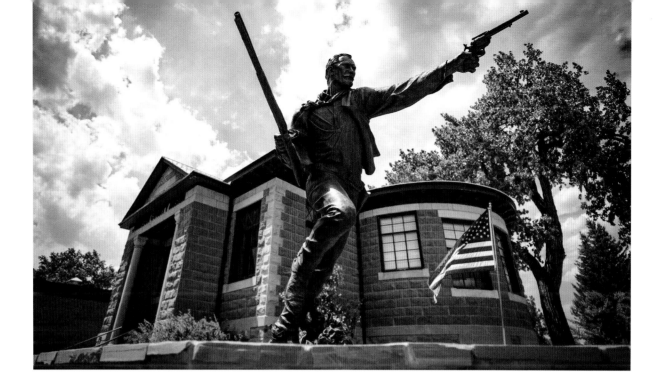

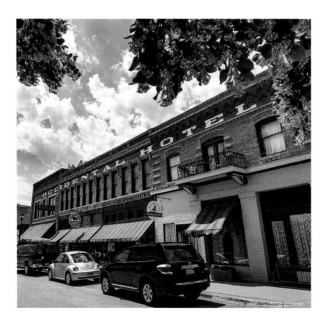

Above: In 1900, Jim Gatchell opened a small drugstore in Buffalo. The Buffalo Pharmacy soon became a watering hole for a wide variety of folks, including ranchers, farmers, scouts, and cowboys. Thanks to Gatchell's close relationship with the Lakota and Northern Cheyenne people, he received many gifts of guns, bows and arrows, medicine bags, and war bonnets. Local residents added memorabilia to Gatchell's trove of historical treasures. After his death in 1954, the entire collection was donated by his family to Johnson County, and became known as the Jim Gatchell Memorial Museum.

Left: The famous Occidental Hotel is among the timeless historic buildings that line the streets of Buffalo. Check in to spend the night in a building that since 1880 has seen the likes of Butch Cassidy and the Hole-in-the-Wall Gang, Calamity Jane, Buffalo Bill, Tom Horn, and a young Teddy Roosevelt.

Far left: South of Lander, Red Canyon was formed about 60 million years ago during the uplift that created the Wind River Range. One of the most expansive views in the state became what it is today thanks to a tilt in the sedimentary rocks and eventual erosion by water.

Above: Libby Flats, the rolling, scenic meadows at the high point on the Snowy Range Scenic Byway, are representative of the tundra-like landscape of the area.

Right: Southern Wyoming's Red Desert offers wide-open vistas. Arid and remote, this high-altitude wonderland is host to an amazing variety of flora and fauna. Adobe Town, shown here, isn't a town at all but eroded badlands—a moonscape that averages only 7 to 10 inches of rain a year.

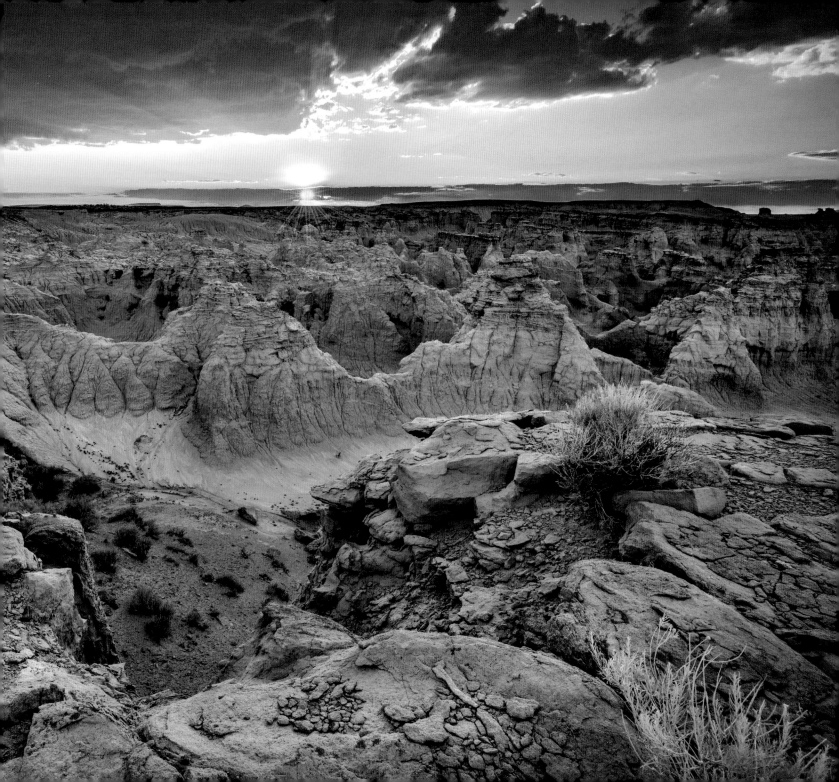

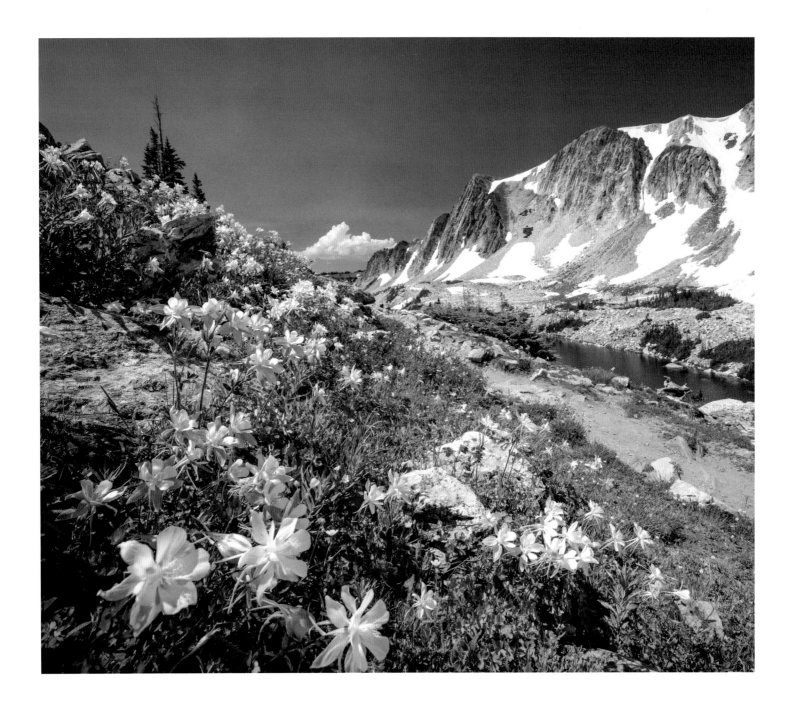

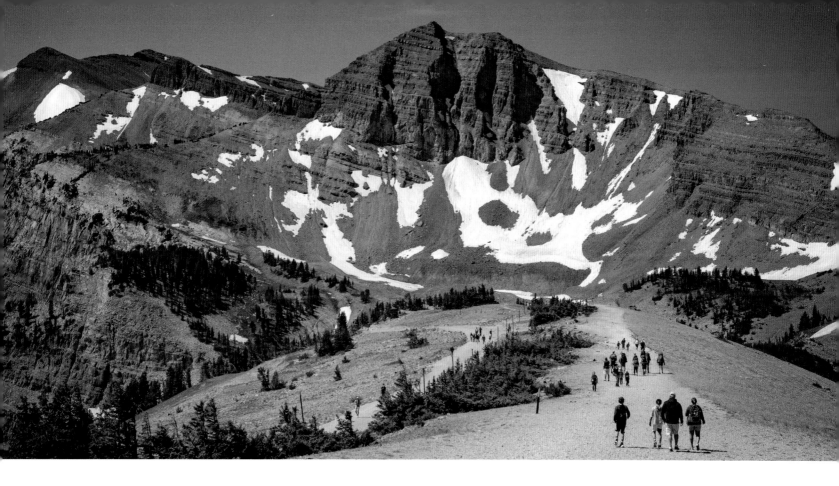

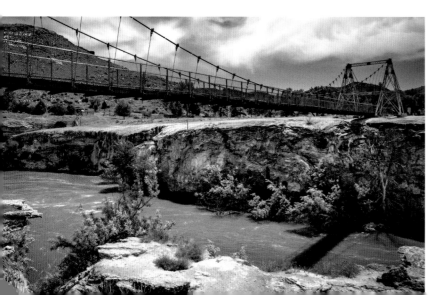

Above: Take the nine-minute tram ride up more than 4,100 vertical feet to the top of Rendezvous Mountain at Jackson Hole Mountain Resort. The Aerial Tram is open year-round to allow adventurers access to a high-elevation playground. Grab a waffle sandwich at Corbet's Cabin and then head out onto the numerous trails at the resort and nearby Bridger-Teton National Forest.

Left: Each day at Hot Springs State Park in Thermopolis, more than 8,000 gallons of mineral hot springs flow from colorful terraces at a consistent temperature of 128 degrees F into the Bighorn River. You can view this geothermal activity from the Swinging Bridge and boardwalks that traverse the ethereal ecosystem.

Facing page: Columbines bloom along the Lakes Trail below Medicine Bow Peak in the Snowy Range. The hike starts with Mirror Lake at the trailhead, passes Lookout Lake, and ends with views of Lewis, Libby, and Klondike Lakes.

Right and below: Near the southwest end of the Bighorn Mountains, U.S. Highway 16 follows Tensleep Creek through a spectacular canyon, snaking between towering rock walls. The area is popular for rock climbing, camping, and scenic drives.

Far right: Straddling the Wyoming-Colorado border due south of Laramie, the 5,118-acre Sand Creek National Natural Landmark showcases the nation's best examples of cross-bedded sandstone and "topple blocks." Ancient sand dunes became petrified and remained when softer sediments eroded away, leaving a grand-scale rock garden.

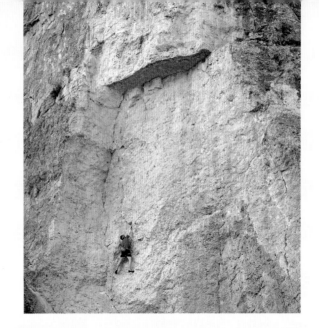

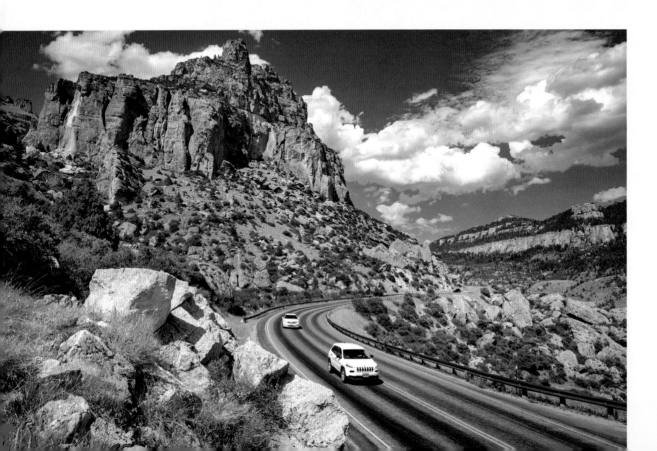

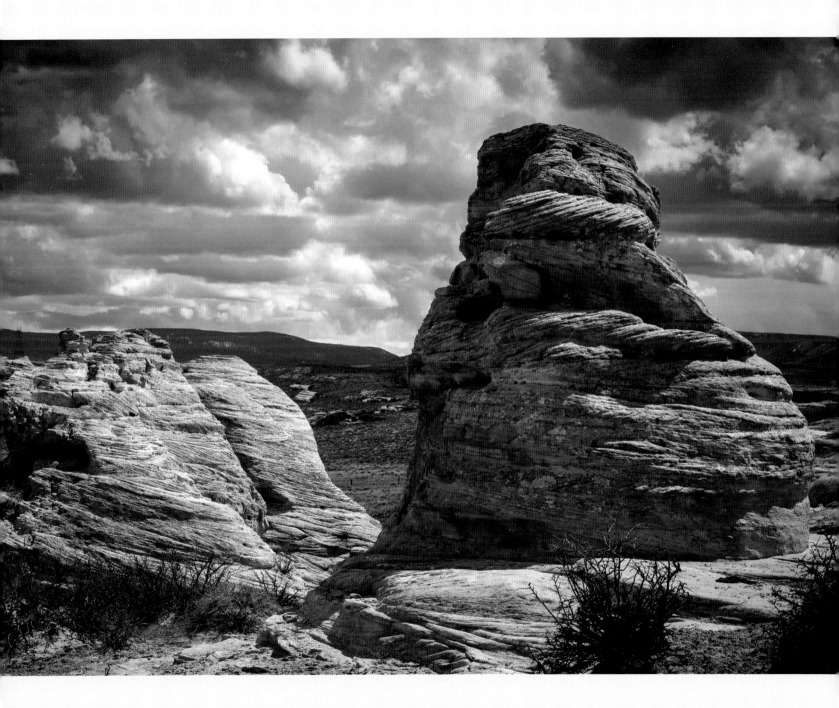

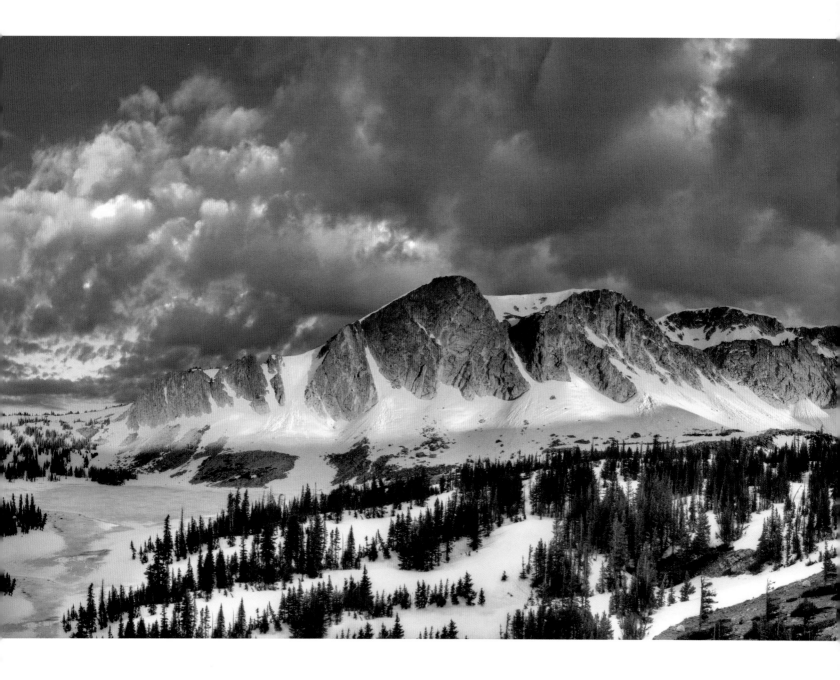

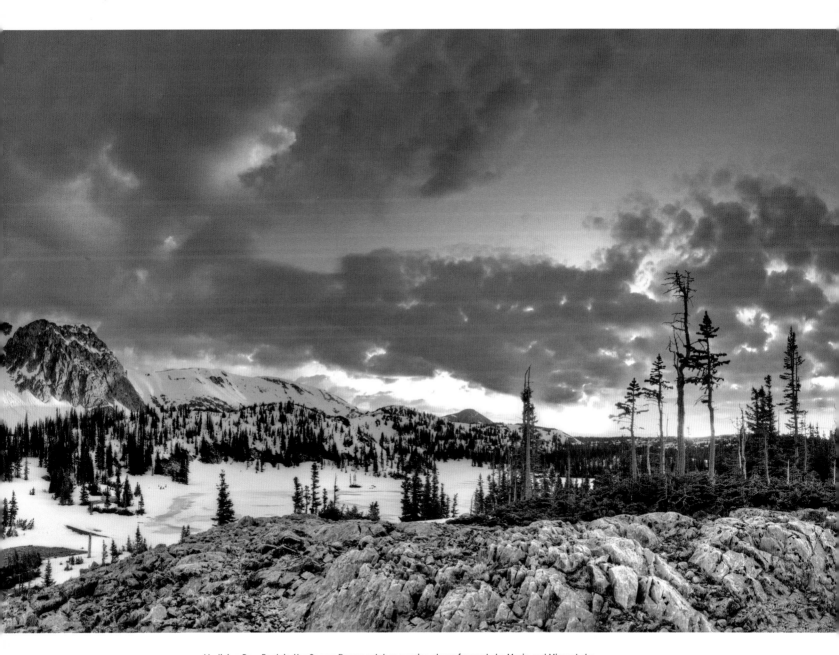

Medicine Bow Peak in the Snowy Range catches sunrise above frozen Lake Marie and Mirror Lake. The area is easily accessible from the Snowy Range Scenic Byway, a 40-mile stretch of road that crests at nearly 11,000 feet and was built in the 1930s by the Civilian Conservation Corps.

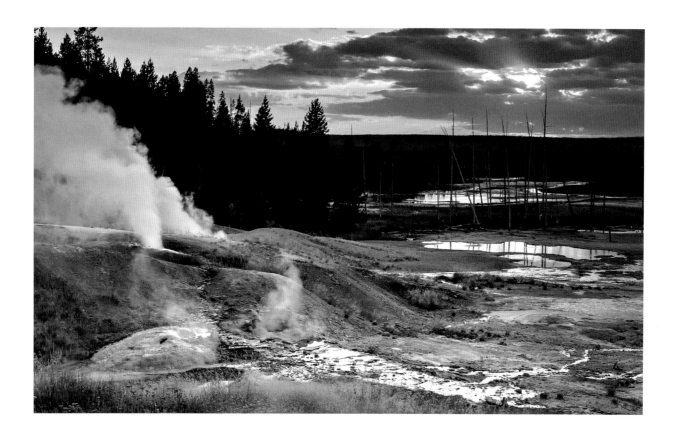

Above: Norris Geyser Basin features a web of boardwalks atop Yellowstone's hottest thermal area. The basin sits at the junction of several fault lines, with molten lava below heating the earth to temperatures above 450 degrees F. Acidic water from the springs kills nearby lodgepole pines, leaving bare trunks as ghostly sentinels.

Right: Yellowstone National Park's bison are special—they are free-roaming and form the largest bison population on public land in the United States, numbering more than 4,500 animals. Bison have lived here continuously since prehistoric times.

Far right: The impressive multi-hued terraces of Mammoth Hot Springs are formed as hot water dissolves the native limestone, redepositing it as travertine. More than 50 hot springs lie close to the two boardwalks that loop through the area.

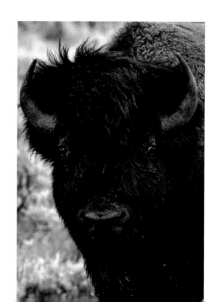

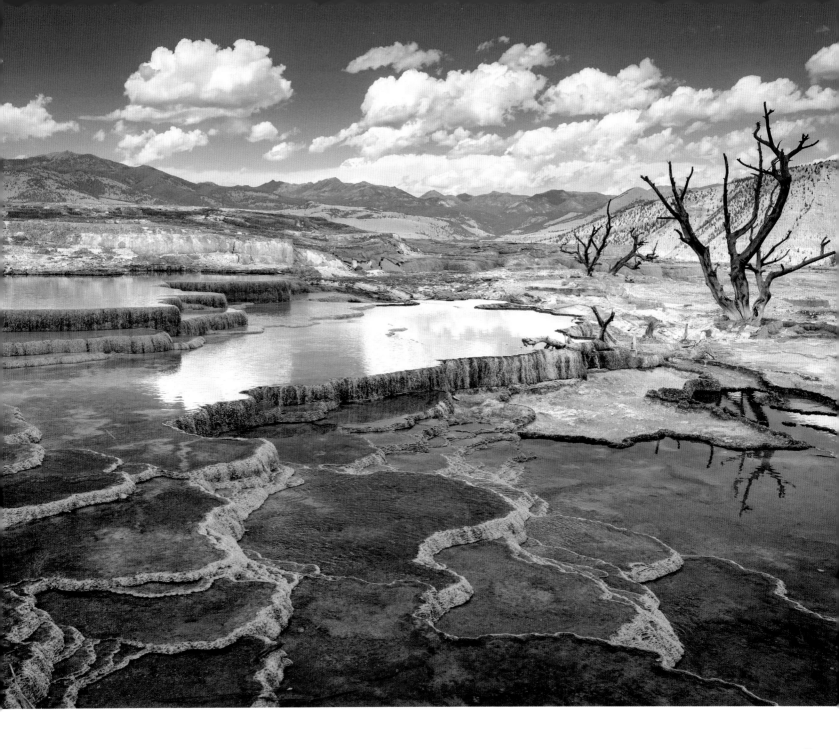

Right: The calm waters of Oxbow Bend, a gold-filled fall valley, and the towering peak of Mount Moran rising above Grand Teton National Park provide the perfect canvas for photographers. The peak is named for Thomas Moran, whose beautiful paintings of Yellowstone helped persuade Congress to set aside that land as the world's first national park.

Below: As you explore deep into the Tongue River Canyon near Dayton, keep an eye out below the 1,000-foot-high rock walls for a glimpse of the old McShane brothers' tie flume from 1894. The flume once carried railroad ties from a sawyers' camp to Ranchester, 20 miles downstream.

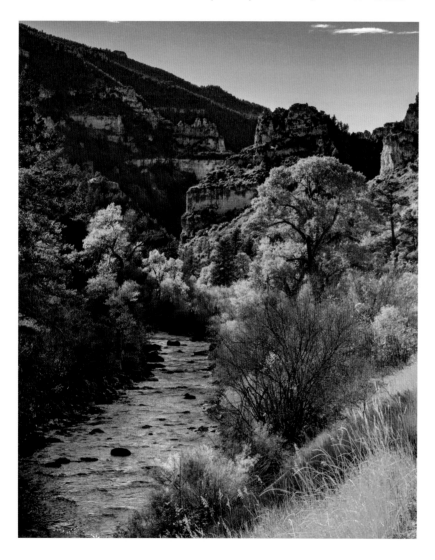

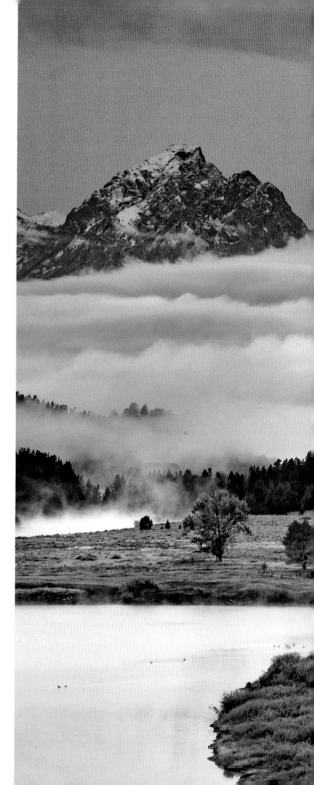

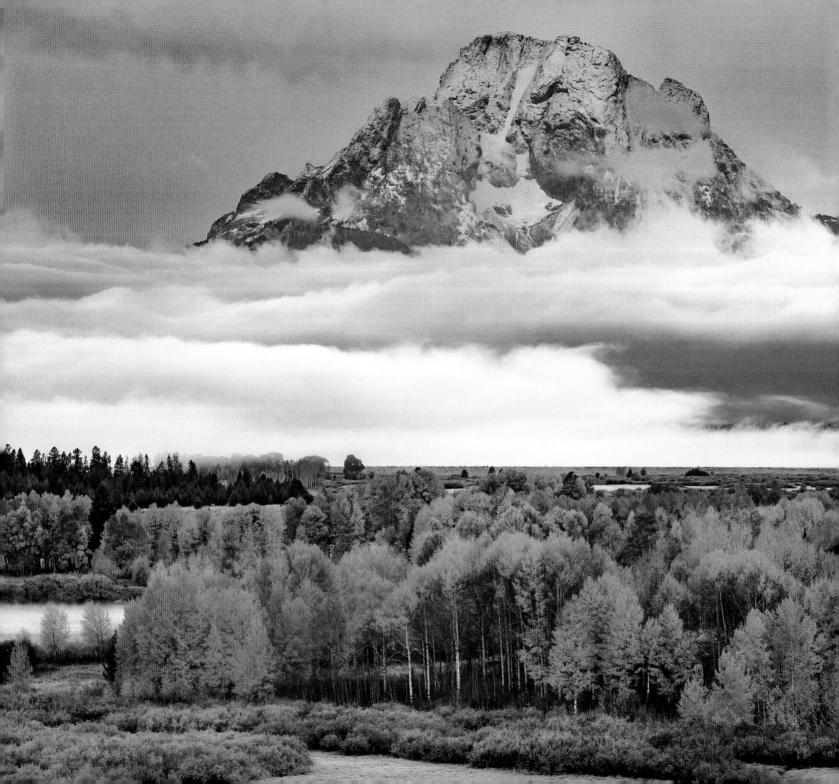

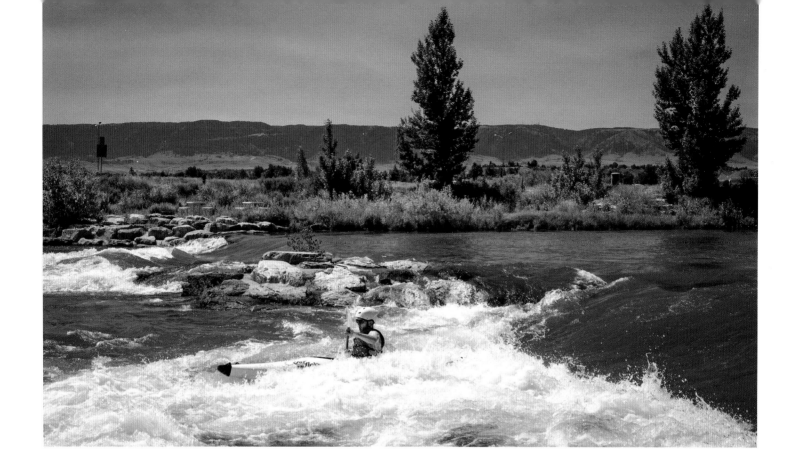

Above: Paddlers hone their skills at Whitewater Park, Wyoming's premier engineered whitewater facility in Casper. Rock features in this half-mile stretch of the North Platte River create a turbulent playground for kayaks and canoes.

Right: The central outdoor gathering place in downtown Casper is David Street Station. Complete with splash pads that turn into an ice rink in the winter, a concert stage, and vendor space, the venue is home to countless events and activities.

Facing page: Clear Creek flows through the middle of downtown Buffalo, providing a scenic setting at the base of the Bighorn Mountains.

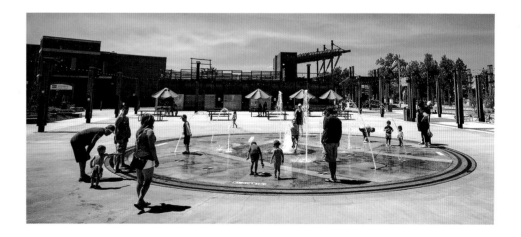

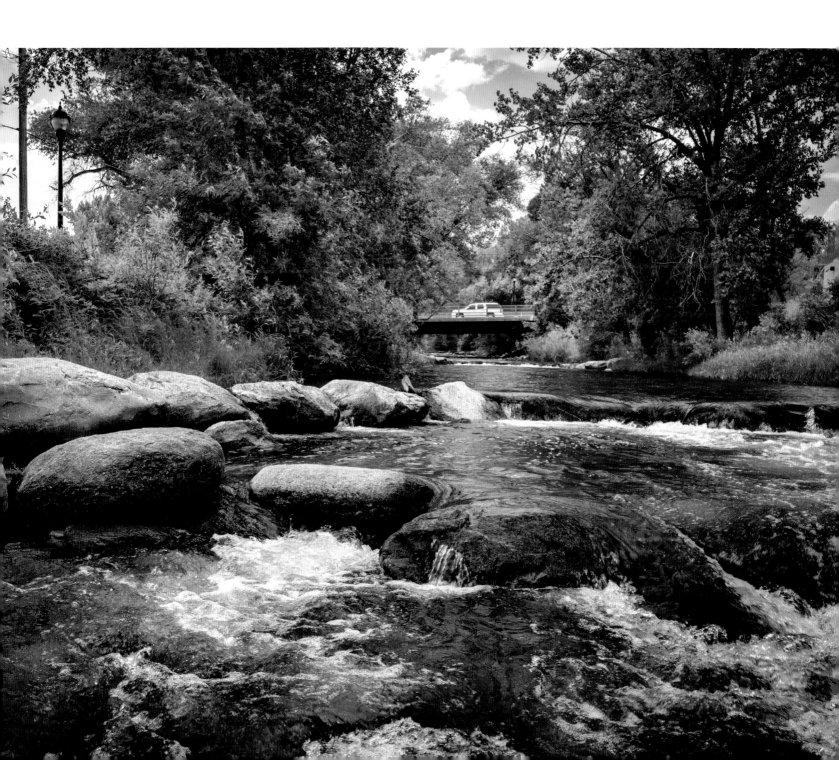

Above: Cody earns its moniker as the "Rodeo Capital of the World" with nightly summertime rodeos and the famous Cody Stampede. Since 1919, this high-energy show with bulls, broncos, and kid-friendly events such as the calf scramble has attracted crowds from June to August.

Facing page: Touted as Wyoming's best statehood celebration, Laramie Jubilee Days started in 1940 to celebrate the Cowboy State's founding. For one week every July, Wyomingites flock to Laramie for nightly rodeos, a parade, carnival, farmers' market, downtown street dances, and beer and food-tasting events.

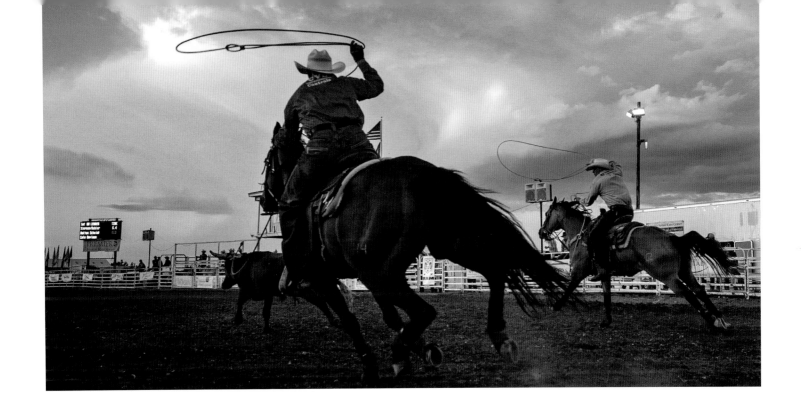

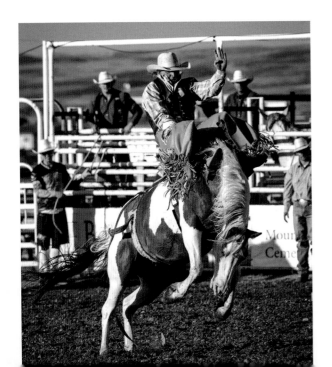

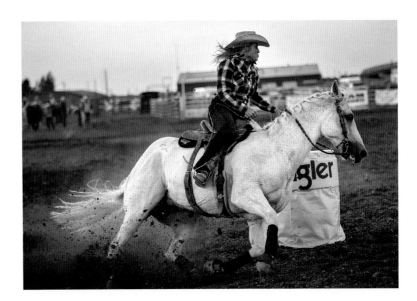

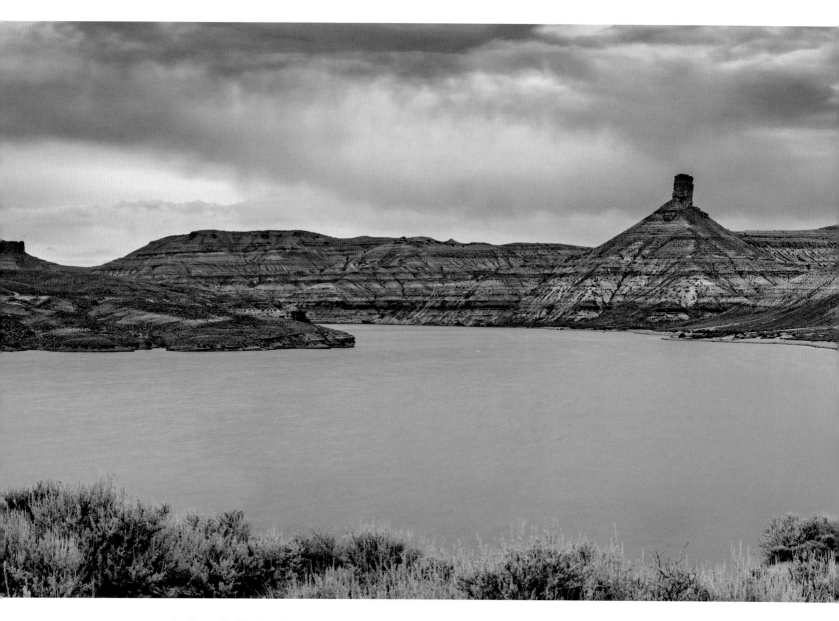

Heading south of the town of Green River opens up a world of adventure at Wyoming's largest reservoir—Flaming Gorge National Recreation Area. More than 160 miles of roads encircle 42,020 surface acres of beautiful blue water. Rugged, dry mountains and eroded badlands rise above a sea of sage and stunted junipers. From the water's edge in Firehole Canyon, visitors can enjoy a panoramic view of two fingerlike projections, North and South Chimney Rocks.

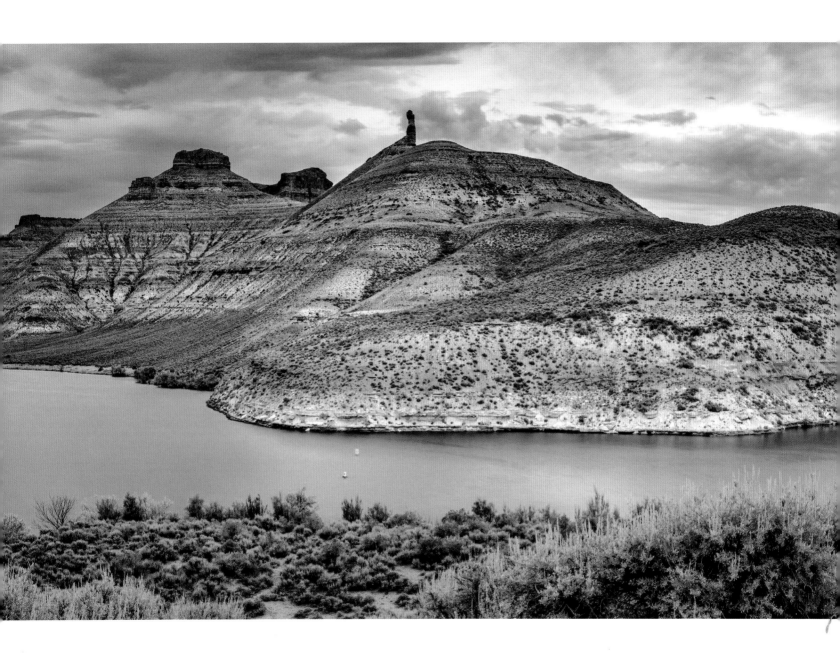

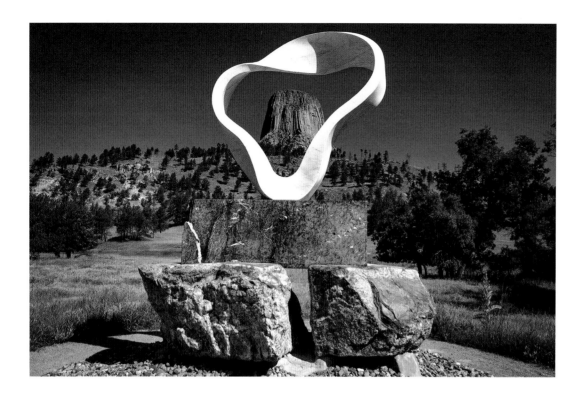

Above: The *Circle of Sacred Smoke*, by Japanese artist Junkyu Muto, emphasizes the importance of Devils Tower to dozens of Native American tribes, many of whom call it "Bear Lodge." The Kiowa tell of a time when a family was camped along the Belle Fourche River. A boy suddenly turned into a bear and began chasing seven girls. To get away, the girls climbed on a rock and prayed for salvation. The rock then grew higher, carrying them to safety while the bear clawed long scratches in the rock. Eventually, the sisters were pushed into the sky and became the seven stars of the Big Dipper.

Right: A male bighorn sheep strolls through a flower-filled meadow.

Far right: Each summer, the high meadows of the Wind River Range glow with color from wildflowers. Big Sandy Lake is a popular destination for hikers, anglers, and campers, thanks to its dramatic views of mountain peaks.

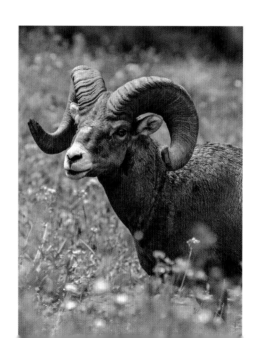

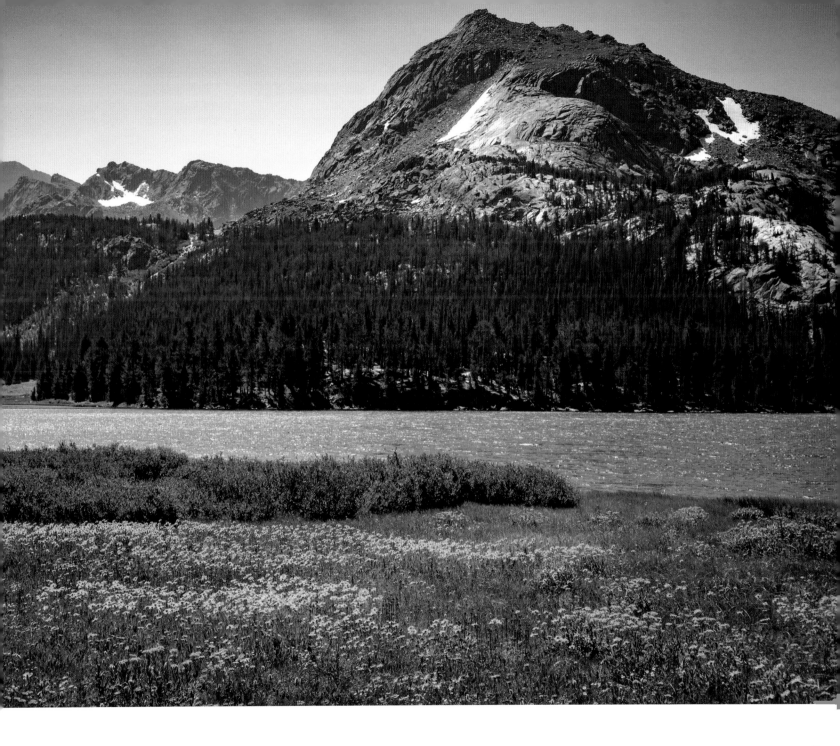

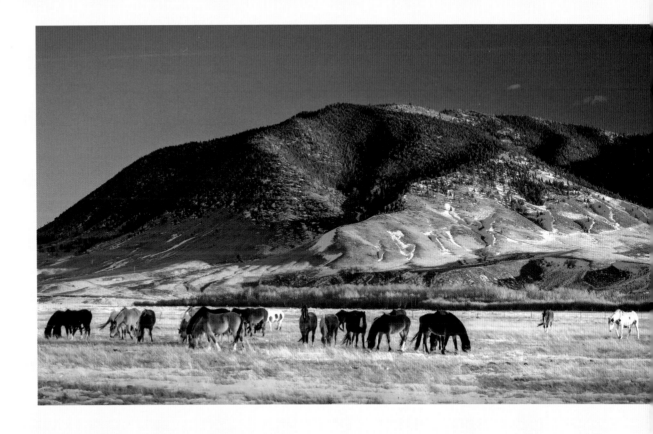

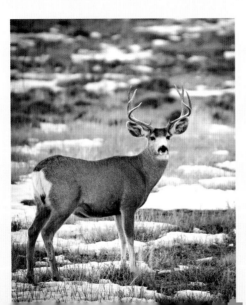

Above: Wild horses graze the pastures below Sheep Mountain near Centennial in southeastern Wyoming.

Left: A mule deer stands alert on a late winter afternoon on the plains of southern Wyoming.

Far left: Laramie Peak is the highest and most prominent peak in the Laramie Mountains. With an elevation of 10,276 feet, it can be seen from great distances, including from the bountiful farm fields of Wheatland and Platte Counties.

Right: The famed Snake River Overlook in Grand Teton National Park is a good spot to savor a summer sunset. The vista became iconic thanks to Ansel Adams's photo taken here in 1942.

Below: Rob Roy Reservoir is the largest of the many lakes in the Snowy Range. The 500-acre lake sits at an elevation of 9,470 feet and is a popular destination for boaters, anglers, and campers. The clear, cold waters are home to brown, brook, and rainbow trout.

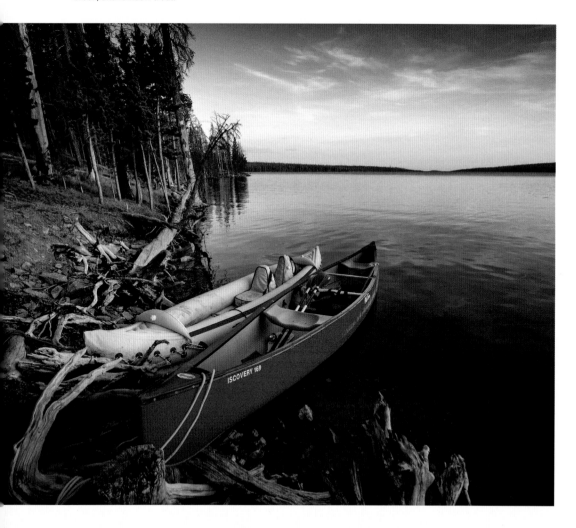

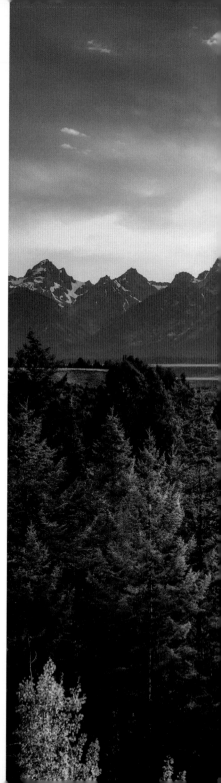

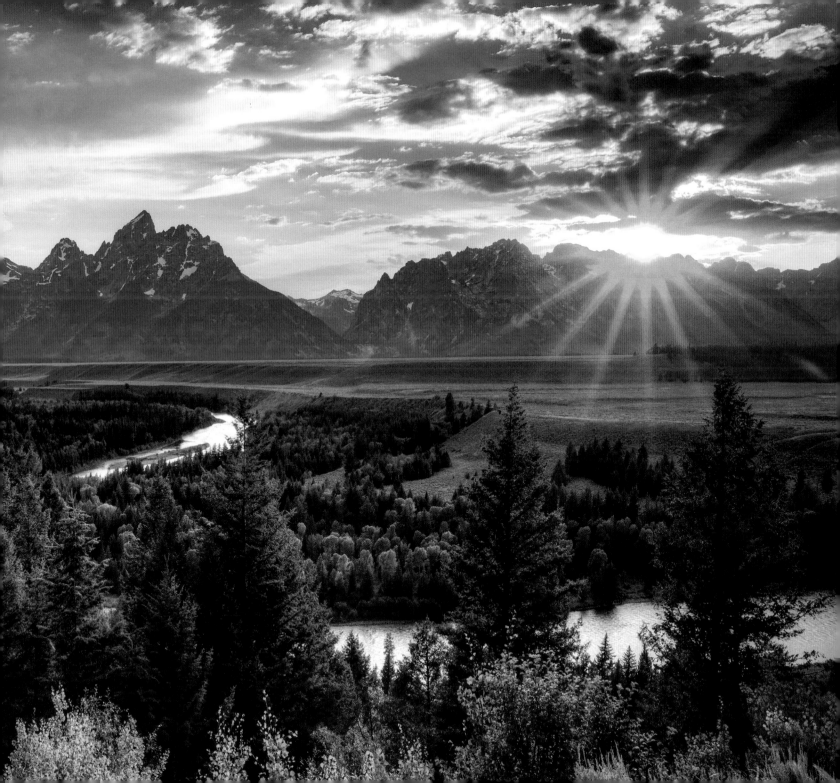

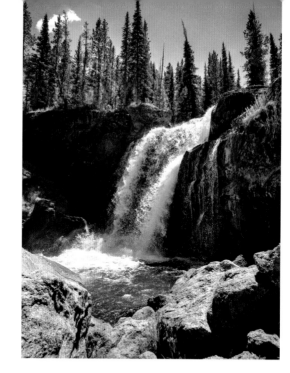

Right: Moose Falls is a 30-foot-high plunge-type waterfall on the southern edge of Yellowstone National Park. Often overlooked by visitors driving into the park, the spot along Crawfish Creek is not to be missed.

Far right: The most famous geyser in the world is Old Faithful in Yellowstone National Park. The highly predictable cone geyser erupts every 45 to 125 minutes. Eruptions can shoot 3,700 to 8,400 gallons of boiling water to a height of 106 to 185 feet, lasting from one to five minutes.

Below: Paired with the world's most well-known geyser is one of America's most majestic lodges, Old Faithful Inn. Constructed in 1903 and 1904, it is the largest log structure of its kind. Made from logs harvested nearby, its steeply angled roofline reaches seven stories high. After a long day of exploring the park, visitors can relax by the warmth of a fire in the 85-foot-tall fireplace.

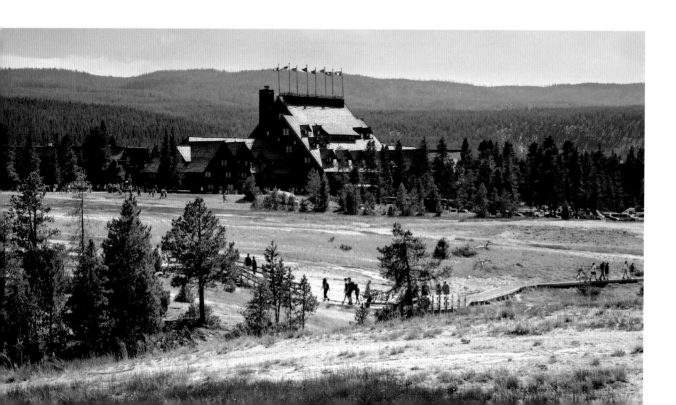

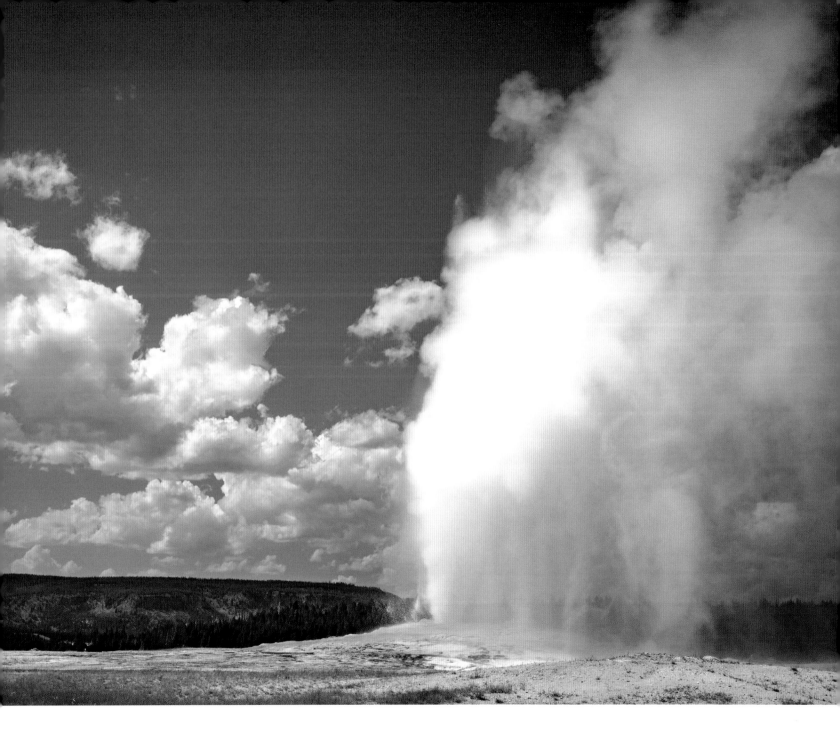

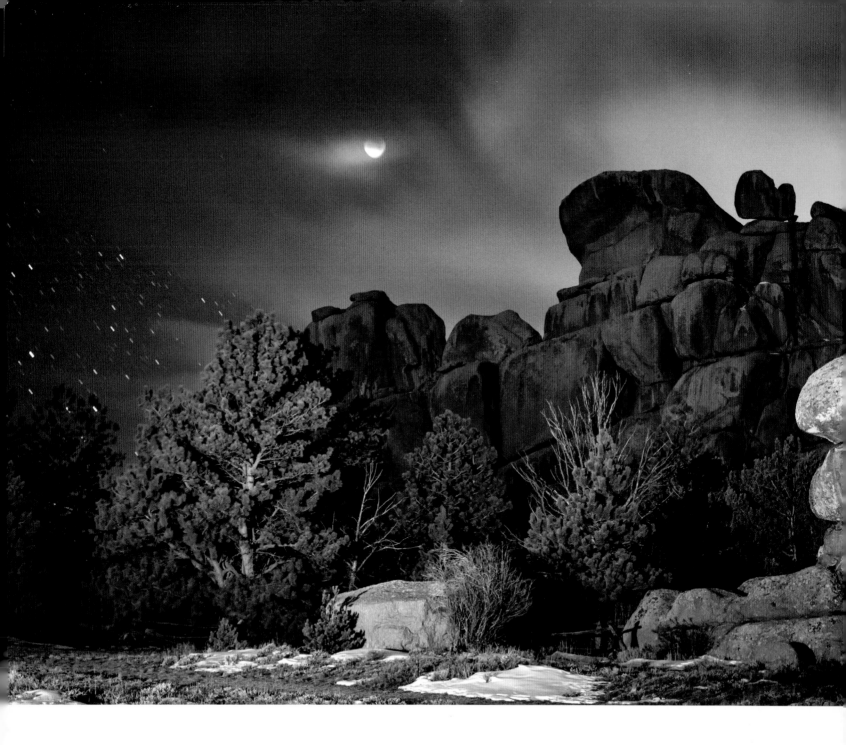

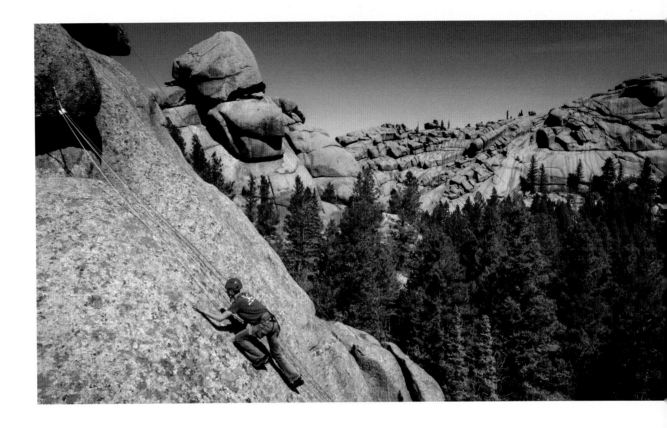

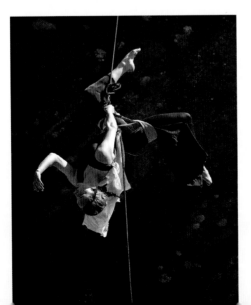

Above: Some of the best rock climbing in the country can be found at Vedauwoo, a beautiful rocky oasis southeast of Laramie. Numerous trails take adventurers to unique views of the quirky rock formations and allow even novice hikers to scramble around the high plains landscape.

Left: Since 1998, the University of Wyoming has held vertical dance performances among the rock faces at Vedauwoo. Intricate rope rigging allows dancers to perform gravity-defying moves, blending performance art, music, and natural elements.

Far left: The name Vedauwoo (say VEE-da-voo) comes from an Arapaho word meaning "earth-born." This area is sacred to the Arapaho.

Next page: Gibbon Falls in Yellowstone National Park tumbles 84 feet. An overlook of the falls is a popular stop on the road between Madison Junction and Norris.

KYLE SPRADLEY, originally from Missouri, now calls Laramie home in the Cowboy State with his wife, Caitlyn, and their two dogs, Jax and Moe.

When not fly fishing or hiking the trails of his backyard, the mountains of the Snowy Range, he works as the photographer and videographer for the University of Wyoming producing visual pieces that are featured in countless print and web publications, magazines, television commercials, and social media channels.

Landscape and nature photography fuel his passion to get out and explore the outdoors. He hopes his work will spur others to go and see their own backyard or work to protect the special natural places in our country.

To see more of Kyle Spradley's photo and video work, visit www.kspradleyphoto.com.